PARANORMAL
SURREY

PARANORMAL
SURREY

MARQ ENGLISH

AMBERLEY

For my Dad

First published 2011

Amberley Publishing
Cirencester Road, Chalford,
Stroud, Gloucestershire, GL6 8PE

www.amberleybooks.com

Copyright © Marq English, 2011

The right of Marq English to be identified as the Author
of this work has been asserted in accordance with the
Copyrights, Designs and Patents Act 1988.

British Library Cataloguing in Publication Data.
A catalogue record for this book is available from the British Library.

ISBN 978 1 84868 896 4

Typesetting and Origination by Amberley Publishing.
Printed in Great Britain.

CONTENTS

FOREWORD
By Dr Ciaran O'Keeffe

'Curiouser and curiouser!' Cried Alice (she was so much surprised, that for the moment she quite forgot how to speak good English).

Lewis Carroll – *Alice's Adventures in Wonderland* (1865)

Since my recent move to the Royal Borough of Kingston upon Thames I've been fascinated by the area. I've listened intently to discussions about the geographical boundaries and borders which seemed to have changed dramatically over the last fifty years. I've smiled at the derivation of the now defunct term *'Surrey Capon'* – a nickname for people from Surrey. I've delighted in driving through Christmas Pie, a hamlet in the parish of Normandy in the Borough of Guildford. I've rediscovered Guildford, the county town, home of the University of Surrey where I was invited to give guest lectures on Psychic Criminology over a decade ago. I've rekindled a love for Hampton Court Palace and its maze that goes back to a single visit with my parents when I was a boy. Of course now I can pop on any number of buses and be there in less than 10 minutes. Then I had many hours drive in the back of an old Ford Cortina TC Mark III. It was quite an adventure.

Nowadays I find myself in quite an adventuresome mood and wherever I go I always search out the weird and wonderful. It was only returning to Guildford recently that I hit on a couple of weird and wonderful facts I was unaware of before. In one of my personal favourite reads, *The Hitchhiker's Guide to the Galaxy* by Douglas Adams, Ford Prefect claims he's from Guildford. Surrey residents and readers of *Paranormal Surrey* will be disappointed to hear that his real home was a planet somewhere in the vicinity of Betelgeuse! Another Guildford factual delight came in the shape of Lewis Carroll, author of *Alice's Adventures in Wonderland* and *Through the Looking-Glass* and two of my favourite poems of all time, *Jabberwocky* and *The Hunting of the Snark*. Charles Lutwidge Dodgson, or his pseudonym, Lewis Carroll, lived for a time in Guildford and is buried in the Mount Cemetery. He famously wrote the words at

the top of the page that Alice recounted as she grows taller and taller after eating a cake labelled '*Eat me*'. '*Curiouser and curiouser*' is a perfect description of the delights Marq English has gathered together and presented in this book.

There are ghost stories that I'm very familiar with and others that were a hauntingly compelling surprise! For example, the patrolling black dog of Betchworth Castle or the spooky ruins of Waverley Abbey. Marq also takes us for a journey through Hampton Court Palace, a location I have a special connection with following my investigation as part of a team from the University of Hertfordshire. I spent two weeks at Hampton Court Palace and marvelled in its numerous eyewitness accounts and fabulous history. Marq, however, does not tread the well-worn path of many ghostly guides by recounting the oft heard stories associated with well known Surrey locations. He also gives some of the locations a very personal edge. Whether it's an intimate reference to his own visit or simply re-telling an experience of a friend, this more personal touch to the guide makes the reader feel he is getting something extra, and that I found fascinating. Fascinating because I never tire of hearing people's haunting experiences and the collection here of encounters with dark figures or spine-chilling screams is no exception. As you take this journey round the weird and wonderful side of Surrey with Marq, marvel in hidden treasures that he's discovered and that we, as a reader, also discover. As someone who has been involved in haunting investigations and experiences for over two decades I'm still amazed at the wealth of ghostly reports and haunted locations still out there. I'm grateful to Marq for showing them to us.

To finish with I'd like to turn to the words of Peter Underwood, author, broadcaster and paranormalist. He's the author of many, many books and renowned in the world of 'ghost-hunting' but, perhaps most appropriately given this current book, he's the author of several county ghost guides: Ghosts of Devon, Cornwall, Somerset, Hampshire, Kent, Dorset, Wiltshire, North Devon. It's his words from 1973 that capture mine and that reflect the excitement I felt in reading about new stories, new locations and, ultimately, to me, new ghosts...

'I have lost count of the number of times I have spent a night in 'the most haunted room', of the hundreds of haunted houses that I have visited, of the thousands of cases of alleged haunting that have come to my attention; but still there is a definite excitement in learning about a fresh haunting, for there is always the possibility that this venture into the unknown may bring a never-to-be-forgotten experience, or better still, that this may be the spontaneous phenomenon that will prove for all time the objective reality of such activity.'

Peter Underwood – *A Host of Hauntings* (1973)

INTRODUCTION

Mention the name of Surrey to most people and images are conjured up of quant villages, the rolling hills of the North Downs and commuter towns such as Guildford and Woking ferrying city workers back and forth from the capital. Indeed, Surrey is a county with a contrasting landscape with vast rural areas battling against the ever-increasing expansion of progress and development in the South East. The county looked dramatically different just over a hundred years ago and one can only speculate what it will look like in another hundred!

But Surrey is a very ancient place with its name derived from the Old English '*Sutherge*' (meaning '*southern district*') and is mentioned as '*Suthrige*' as far back as AD 722. From the 1400s onwards, Surrey was divided into multiple hamlets of Blackheath, Brixton, Copthorne, Effingham, Elmbridge, Farnham, Godalming, Godley, Kingston, Reigate, Tandridge, Wallington, Woking and Wotton. Even up to the beginning of the twentieth century, Surrey was still largely a rural landscape with agriculture being the main industry. This remained constant until rapid suburban expansion occurred between the two world wars.

In 1965 the London Boroughs of Croydon, Kingston, Merton, Richmond and Sutton were created to form part of Greater London. Some may argue that Surrey lost a little of its identity when this merging occurred but the county retains many of its mysteries hidden among the numerous hamlets, lanes and buildings both old and new. For the purposes of this book, I will be recognising the pre-1965 Greater London boundaries.

Having grown up in the county since the early 1970s, I've had many an opportunity to visit and explore many of the fine locations that grace this part of the South East. There are of course many famous places, old villages and towns in Surrey bursting with history and heritage despite its proximity to London. There are the remains of fine castles at both Guildford and Farnham, the grandeur of Regency design at Polesden Lacey, there's the first Cistercian Monastery in England at Waverley Abbey, the seventeenth-century Moor Park House is where *Gulliver's Travels* author Jonathan

Swift stayed for a time, at Runnymede in 1215 Prince John reluctantly put his seal on the Magna Carta to appease the Barons and of course there is the magnificent Hampton Court Palace on the River Thames, forever associated with King Henry VIII and his many wives. These places are treasure troves full of fascinating history but as well as the obvious documentation of historical essays; many locations have their fair share of folklore, legends – and *phantoms!*

I've had the good fortune to have investigated many alleged haunted places all over the country including manor houses, castles, pubs, private houses, inns, secret bunkers, ancient woodlands, churches and even a football club, but have a particular attachment to the South East with its varied and fascinating locations. Indeed, read David Scanlon's excellent books *Paranormal Sussex* and *Paranormal Hampshire* about the many haunted locations of this area within the South East, including many locations I've been lucky enough to have either visited or investigated.

The title of this book is *Paranormal Surrey* and I'm sure many people interested in the vast subject of the unexplained will know that the word '*paranormal*' covers a multitude of topics as diverse as cryptology, UFOs, ley-lines, crop circles – and of course *ghosts!* Most people will know someone who has had some kind of weird ghostly experience and these can be a truly frightening experience. Of course what maybe paranormal to one person might be something completely natural to another.

So what is a '*ghost?*' Not an easy thing to define and everyone will have their own opinions and theories of what a '*ghost*' is? Is it a recording of a past (or maybe future) event played out when certain conditions are right? Is it an anniversary of a tragic occurrence or of an intense emotional episode that left its mark on a property? And if these are just recordings (residual energy?) then it will be inert to our communication and all we can hope for is being in the right place at the right time. And what about '*spirits*'? Are they actual entities that have passed to another but unseen dimension but have the ability to return to our earthly plain? A medium once explained his theory to me saying '*for spirit, it's just like popping back to look at an old family photograph album*'. And are poltergeists (a German word meaning '*noisy spirit*') responsible for emotional and often violent occurrences like the famous Enfield poltergeist case?

Or are they all just figments of our imagination? As it's often said '*extraordinary claims require extraordinary evidence*' – and has there ever been anything tangible to at least support a strong working theory about ghosts? There seems to be plenty of photographic, audio (EVP – Electronic Voice Phenomena), light anomalies, temperature changes and atmospherics gathered as potential evidence of paranormal activity but how reliable is this on something that hasn't ever been proved? Even if someone was lucky enough to capture a full apparition on photograph or video, there will always be the hardened sceptics who offer alternative explanations or merely dismiss it as a hoax! Unlike studying for example, crop circles – here you have the means to take physical evidence of affected corn into a controlled environment or laboratory but with ghosts it is much more difficult to define parameters of study with so little '*evidence*' to go on despite the continuing claims of unexplained activity.

So where do I stand on the existence of ghosts and spirits? At the time of writing this book I have never seen a ghost or an apparition but have had a few experiences

that I could, at a push, define as *'unexplained'* even after hardened critical analysis. This incredibly complex universe we live in still holds back many secrets that have yet to be explored by conventional science and one can only be optimistic at what will be discovered in years to come.

But back to this supernatural tour of Surrey. Although I will take you to some of the more prominent locations of the county, I will also visit the places that maybe not be as well known as others. Some of these locations have been investigated over the years by myself or with my *Spiral Paranormal* team – *www.spiralparanormal.co.uk*, others are personal statements which have been taken from eye witness accounts or are some of the already existing legends and folklore that have built up around many places in the county.

One thing I will not be doing however is making claims about Surrey being the most haunted county in England (a rather odd statement to make really – how does one measure this?) but it does have a wealth of intriguing tales to tell. You, the reader, can decide whether they are paranormal or not.

Finally, the book has been written in a handy A-Z format for easy reference and is part guidebook, part gazetteer and part history book and I do hope you will enjoy the many tales from Surrey's rich paranormal landscape. This book will be your guide to the haunted places of the county which I hope will inspire you to seek out your own research into the ghosts of your own region – which maybe a lot closer than you think.

Marq English

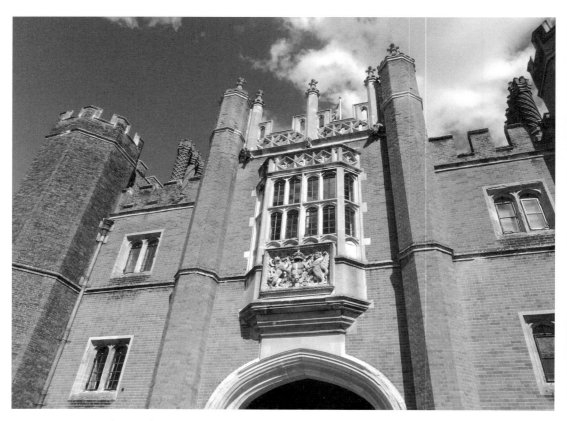

Surrey's most famous historical building experiences a great deal of paranormal activity.

ACKNOWLEDGEMENTS

Many people have generously contributed to the authoring of this book and I would like to thank in no particular order Norie Miles of *Out There Media*, Tom Heron, Giuliano Zampi, the team at *Spiral Paranormal* past and present – Alan Barnett, Patricia Waterworth, Annalisa Foster, Mandy Gibb, Al and Kat Piddington, Duncan Williams, Vicky Richer, Nikkie Pegg, Rosanna Collins, Sara Tolliver, Anna Leeson, Alexis and Byron Holloway, Hannah Ebert, Lisa Biddle and Kathleen MacNamara, to Andrew West of *Surrey Paranormal* for his exhaustive research into the A22 ghost, Rob Martins, Marion Bridger, *Beyond the Senses* shop in North Cheam, Jane Furnival at *The Old Rectory*, my Mum, Maurice Wareing and staff at *New Wimbledon Theatre*, Val Hood, Paul Cissell, Mark Webb, Denise and Richard Mott of *Compass Paranormal Events*, Sam and Gary Brown of *UK Paranormal Network* for their continued support, my (very) patient editor Sarah Flight and to Dr Ciaran O'Keeffe for his excellent Foreword to this book and the discussions on the psychology of paranormal experiences.

Thank you all very much.

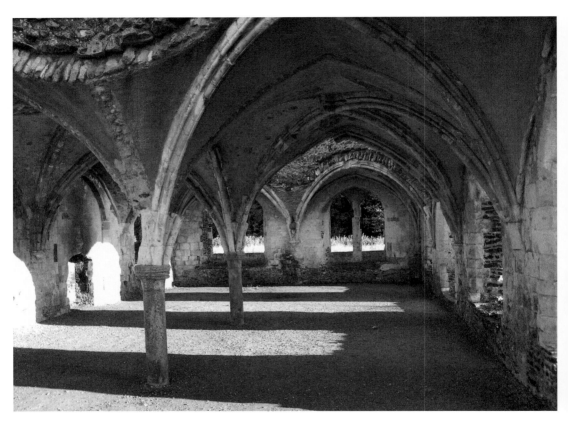

The first Cistercian Abbey in England has many reports of ghostly monks seen among the ruins.

A–Z OF HAUNTINGS

A22 CATERHAM BYPASS

Caterham

There are many accounts of spectral sightings on England's roads and Surrey is no exception. In recent years, one intriguing report that continues to have eye-witnesses concerns a sighting seen on the A22 approach to Caterham.

Usually occurring in the early hours of the morning, drivers have reported seeing a dishevelled young girl stumble across the road and vanish into woods opposite. Some people have been so startled by what they've seen, police have been called out to investigate but no one is ever found.

My friend Andrew West has not only done extensive research on the A22 ghost sightings but has actually seen the apparition for himself.

'It was a December morning and the weather was cold as it would be for this time of year but there was little wind and it was dry. I was with my friend Angie and took the A22 turn off on the M25 and proceeded up towards Whysleafe. A few miles up the road are a set of traffic lights where you can turn left which takes you into Caterham Valley and the road that carries straight on is the A22 Caterham bypass. The lights turned green and I set off. We were the only car on the road on that dark morning and the time was approximately 5.30am.

About two-thirds of the way up the road we saw a girl walk from the central reservation across in front of the car towards the path on the opposite side of the road to my left. She did not look to see how far away I was – which is a natural thing for anyone to do even if you were drunk! I remember thinking that perhaps she had been to a party but where she had come from was very rural with just a couple of houses and Tillingdown Farm. She was wearing a short blue denim skirt, a white summer

t-shirt or blouse, white tights and a soft '60s style floppy leather type cap. She had shoulder length blond hair but I could not see her face. I also remember thinking at the time that she looked greyed out like she was not in full colour. I figured she must be very cold but I really didn't think much about it as I had never heard of the Caterham bypass Ghost at that point!

The girl reached the path on my left and she just stood there staring into the trees standing still as I passed. Angie said 'Do you think that's the A22 ghost?' in an alarmed voice and I said that I didn't know what she was talking about so she explained to me the story of the ghost. She said that the girl had lived in one of the tied cottages up near Tillingdown Farm. She walked down the access road and down some steps to the A22 where she was run over and killed while crossing the road. Opposite the steps on the opposite carriageway there is a path that winds its way down to Caterham Valley which was where she was going I should think. When we returned to my house Angie went home and I searched for information on the internet later that morning.'

Andrew did indeed find more information about the A22 ghost and to his surprise found several reports stating that other eye-witnesses had seen the very same girl that he had. Even his wife who is very cynical about these things was surprised at what was uncovered. One report told of the girl being in distress with torn tights and a police helicopter being called to the scene but no one could be found. Andrew found this very interesting and created a website dedicated to the apparitions and to see if I could get any more information from other witnesses. Before long he started to receive emails from people who claim to have seen the girl. From all the reports that he received there seemed to be a pattern emerging.

There were accounts of three different apparent spirits being reported, all girls but with differences. A few reports were of an eighteenth century figure in a white smock or nightie, one was of a girl with long dark hair, pleated short skirt, knee length boots and spent a lot of the time jumping in and out of bushes along the A22 and the last was of the girl that Andrew saw.

In April 2009 Andrew moved to a local police station for work which was very handy for information on the girl. Fuelled by all the stories of this ghostly girl, it was at this time that Andrew started going on ghost investigations with the brother of a friend of his who was also interested in the paranormal. Having been on a few investigations before he decided that it may be a good idea to form his own paranormal investigation team and formed *Surrey Paranormal*. While this was going on, a report was published stating that the A22 Caterham bypass ghost was one of Britain's most reported sightings.

A few days after the report was published Andrew was called at work to go and pick up his youngest son from school as he had been sick and needed returning home. This was at approximately 10.30am so at about 11.30am (after sorting his son out and putting him to bed) he checked his emails. Andrew was very surprised to recieve an email from the ITN news desk asking him to call them regarding the A22 ghost sightings. He did so and it was suggested that he was interviewed that afternoon by reporter Glen Goodman. Andrew agreed and appeared later that evening on the *London Tonight* programme (Andrew told me that whilst being interviewed he was

shaking like a leaf – that's without any ghosts present!) Indeed, it was the scariest thing he had ever done, far scarier than hunting for ghosts!

Soon after the programme was broadcast, he received many emails from people who were claiming that they had seen the ghost. Many were very similar but one really stood out from the rest. He received an email from a woman called Carol who claimed to have lived in one of the tied cottages up at the nearby farm. She had lived there with her family from 1972 until 1978 and her husband worked on the farm with the house coming with the job. She wrote:

> 'My son, who now lives in Plymouth, was searching the history of the Caterham area last evening, and came across your website. With great excitement he 'phoned me to tell me all about you. Myself, my husband and our three children used to live at Tillingdown Farm which is approached via the turning off the southward carriageway of the A22, just before the southern entrance to Caterham, and within the area of sightings of a ghost, as shown on your map. (There use to be an 'AA' Box at the turning years ago.)
>
> We lived there in the early 1970s, when it was a horse-racing yard. With my children, Peter and Aubrey walking and baby Fiona in a push-chair, I used to walk down to Caterham to get food shopping etc. We would walk down a footpath to the A22, and cross to the centre of the road, which in those days was just a hedge, and get across to other side, through the woods and on down the many steps to the town. It makes me shudder to think of the risk but I had no choice, I didn't drive a car. I don't remember seeing anything unusual in that area, I think I would've been too busy watching the traffic, counting the steps and dragging the push chair!'

This was very exciting to have someone who actually lived up at the nearby farm who had different experiences from those on the bypass. Andrew's team at *Surrey Paranormal* have since been to the farm on several investigations – one of which was with Carol and one of her sons in attendance. He told me that it was a very interesting evening with weird noises, lights, smells and possibly the ghost of a shepherd who hung himself in the house after losing his sheep to heavy snow.

But it doesn't stop there – many other reports concerning the A22 ghost follow:

> 'What was weird about it was that we didn't see her until we almost got to her, and it was freezing out yet she was wearing next to nothing, plus she was on her own in the middle of a dark street. She didn't look like she was about to cross the road, she was just standing there. We both commented on it and I looked back in the mirror and she'd just gone. Very odd!'

> 'My friend was driving, when suddenly we saw a female run across the carriageway from right to left in front of the car and run down in the woods, we were obviously both shocked and my friend braked hard so as not to hit this female. She was dressed in knee high black boots and a short dark coloured mini skirt. I could not see what she was wearing on the top half of her body and her face was what I can only describe

as 'no features' and she had long darkish hair, but all this happened so quickly ,we thought she may have been out partying and in all honesty we thought no more about it. I never even knew about this supposed ghost until about a year later another friend whom I had mentioned this to at the time told me she had overheard a conversation about the A22 ghost – only then did I realise what we had seen. Although I am very much a sceptic, I am absolutely convinced that on that morning I saw a ghost...'

'I work for the Met Police whereby I travel to and from work in Croydon by driving up the A22 from my home in Godstone. I have often thought how creepy the road is at times and have seen a few really nasty accidents on that road since living in the area – one of which made my blood run cold. Anyway back in 2008 around mid autumn I was on my way home from a late shift at work, I had driven down the A22 heading towards Godstone. Just after the junction where the valley joins the bypass I had a feeling that someone was watching me – as I reached the footbridge that crosses the A22 and just after the small industrial estate I looked in my rear view mirror. It was then I saw a young girl sat on my back seat, I wouldn't say she was wearing a cap but she had a white top on and I would say her hair was fair. By the time I had driven under the footbridge she was gone, I remember driving the short distance home questioning myself as to what I had seen.'

'We went to the site just last week and sat in the lay-by just after the staircase. Two people stayed in the car and me and a friend got out. We walked just over the hill from the road to the back were there is some sort of small slip road which if you carry on walking up to the top of you end up at the top of the staircase. Unfortunately we did not get this far. We just got onto the road when we heard someone shout out Tom or John? I'm not sure if these names mean anything to you but it was definitely said in a woman's voice. Then behind me my friend saw something run very fast towards where the car was sitting in the lay-by. The two people still in the car had a large twig thrown at the window. After this we left because a few of us were quite shaken. I think someone or something was trying to have a laugh with us or just did not want us there – but I can say it worked because we left.'

From all the reports Andrew received, there seemed to be just three types of ghosts. The most uncommon one is of a girl that looks like she is either in Victorian clothing or a nightie. One that is seen most regularly is the one he saw and the third could possibly be a male who dresses up in women's clothing and runs across the A22 during the day and night (yes really!). He has been active for a few years it seems but was finally arrested in January 2009. Reports of this ghost were first recorded in 1962 and Andrew has seen a picture of the male that was arrested and he looked about thirty-five years old and would not have been born in 1962.

The ghost (the *real* one – if there is such a thing) only shows herself to vehicles that are on their own in the early hours. It has been reported that she has been seen in the woods opposite the steps as lights have been seen and photographed in the woods. A couple of reports state that the girl gets noticed standing in front of a parked car or

lorry in one of the many lay-bys there and when the driver exits his vehicle the girl disappears and reappears instantly 50 yards down the road!

People have chased her up the stairs only to find she has disappeared when they get to the top. Andrew also had a few reports where people have stated that when chasing her she always remains the same distance away from the person chasing her so if they run quickly the girl seems to go faster, if the chaser stops, she stops! She has also been seen looking to the ground as if she is looking for something and there have been reports of glowing lights on the floor but she is not holding a torch!

The mystery of the girl may never be solved but Andrew and *Surrey Paranormal* will endeavour to do what they can to get to the bottom of this intriguing phantom. *Surrey Paranormal* have performed a number of investigations at the site and nearby locations (including myself and the team at *Spiral Paranormal*) and plans to go back with various mediums to see if they can pick up on the stories that we know about that are not readily available in the public domain. Some members of the public have also been kind enough to do their own investigations here and pass on any information and images to Andrew so to build up as complete a report as possible.

One last account from this area dates back from the early 1960s. Several motorists reported seeing eight figures dressed in black cloaks or cowls running and leaping around, heading towards the dual carriageway. The witnesses said that they moved strangely and silently – is the A22 near Caterham one of the most paranormally active roads in the country? You decide!

A217

Godstone

The following account took place in November 1990 as a friend of mine called Tom was driving from Sutton to Godstone.

It was a dark, drizzly Tuesday evening and Tom was driving his (fairly new) Renault Savanna from Sutton to Godstone. Alone in the car and listening to some mundane radio station, he turned off the A217 (over the M25) heading for Godstone. The sky was starting to darken, the traffic was non-existent and visibility was still very good. In the distance Tom could see some low lying mist lying over the top of the fields just near the motorway. The temperature was quite mild for this time of the year so was not surprised to see mist! But disregarding his lack of environmental knowledge just ignored the mist and continued to drive along the country road. However, in his ambient vision he sensed that the mist in the field about 200 yards ahead was moving and expanding towards the road. Driving on up the road the mist moved across ahead of him and converged together.

Just as the mist started to cross the road and over my car and could see that the road ahead was clear, the headlights, sidelights, dashboard light and radio suddenly went off! Tom realised afterwards that all of the electronic equipment (i.e. speedometer, petrol gauge etc.) had also stopped. The mist suddenly became a dense fog. Common sense would have suggested stopping the car as near to the kerb as possible and waiting

for the mist to move on, but because he knew the road ahead was clear, he accelerated through the mist and continued in the darkness.

The following day, Tom drove back to Sutton and took the car into a Renault Garage in Coulsdon. The mechanic explained that almost all of the fuses had blown and commented that he had never seen so many independent fuses on separate electrical circuits blow out at the same time.

As a footnote to this story, it's worth noting that Tom is a logical, trained scientist (PhD) and to this day has no rational explanation for what occurred!

A3

Burnham

This is a very sad and tragic story and only occurred recently in 2002. The Burpham stretch of the A3 near Guildford is a particularly busy one and during the late evening of 11 December 2002, Surrey police received a number of calls from motorists travelling along that section of road. Callers were reporting a car apparently losing control and swerving off the road with extremely bright headlights.

On arrival at the scene however, officers could find no immediate or obvious evidence of a recent accident. On closer inspection and with further investigation, they uncovered a Vauxhall Astra containing the decomposed body of a man. The car was found buried in the undergrowth and though not visible from the road was only a few metres away from the reported site of the 11th December accident. The car's battery had long-since died but closer inspection revealed that the headlights had been set to full-beam!

Forensics suggested that the accident had occurred the previous July, some *five months before* motorists reported seeing the vehicle leave the road at high speed and that no other vehicle had been involved. Dental records were used to identify the unfortunate driver who had been reported missing by a relative in July 2002.

No further sightings have been reported on this stretch of road. Could this lend weight to the theory that spirits can consciously manifest themselves for a purpose – in this case, to enable police to locate the driver's body so that his family could lay him to rest? Or was it a simple, straightforward *replay* of past events?

A324

Pirbright

One evening in 1995 a male driver was travelling along the A324 towards Pirbright. He was startled to pass an old-fashioned bus coming from the opposite direction. This might seem odd enough but no sound or exhaust fumes were evident as the two vehicles passed each other with the driver commenting that his cars headlights did not reflect of the bus!

From the description given, the bus was identified as a '*Dennis J Type*' of *The Aldershot and District Bus Company, which* was in operation back in the 1920s.

ABBOT'S HOSPITAL

Guildford

As Ciaran pointed out in his Foreword to the book, Ford Prefect in *The Hitchhiker's Guide to the Galaxy* was not from Guildford after all but from a small planet somewhere in the vicinity of Betelgeuse! Ford however would have been proud to be a resident here with the town's ancient origins stretching back to Saxon times. Having been founded in the fifth century, Guildford now lays claim to be the capital of Surrey and you can spend a whole day here exploring its many lanes and historic properties that nestle around the steep ancient High Street running down to the River Wey.

At the top end of the High Street is an almshouse known as the Abbot's Hospital, which was built around 1622 by instruction of George Abbott. Born in 1562, Abbott was a Guildford man who rose in prominence to be Archbishop of Canterbury from 1611 to 1633. This beautiful building stands opposite the Holy Trinity Church where George Abbott now rests.

In July 1685, the Duke of Monmouth was held prisoner in the Gatehouse on his way to London and his execution at the gallows. The Duke was the illegitimate son of Charles II and was part of a movement to prevent his uncle James, Duke of York from becoming the next King of England but his planned seizing of the Crown never happened with many of his supporters captured or killed.

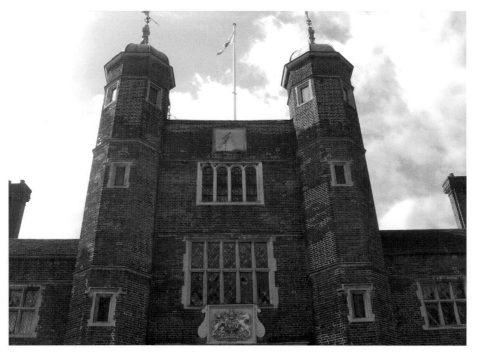

Does the ghost of the Duke of Monmouth still reside in the Gatehouse before travelling to his execution in London?

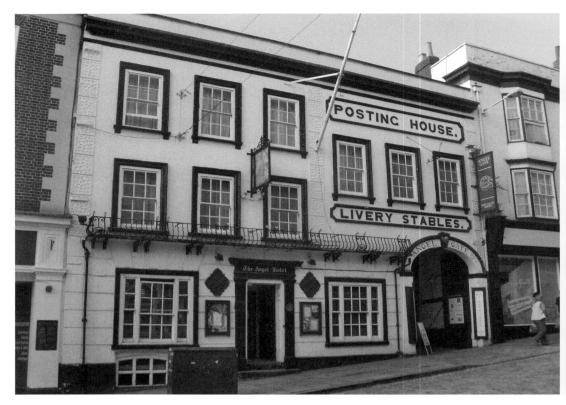

Have former occupants of the Angel Inn not yet checked out from the hotel?

It has been said that a man who haunts the room above the Gatehouse is that of the Duke of Monmouth himself. Could this be a residual haunting as the phantom waits in eternal anguish about his fate – and the prospect of the execution block?

ANGEL HOTEL

Guildford
Staying in Guildford, The Angel Hotel is a beautiful timber-framed building nestled in the heart of the town's historic High Street and was built on the site of an older Monastery. The oldest part of the building dates back to the 1300s with the earliest recorded document of the property being a deed from a gentlemen called Pancras Chamberlyn in 1527 when Sir Christopher More bought the building for £10.00. More's son also built the nearby Loseley Place (*see separate entry*). The building also has a medieval crypt that used to be a restaurant.

Being situated in such a prominent position as Guildford was on the main route from London to Portsmouth, many travellers and merchants would have used the hotel as a stopping point. This continued for many years until the coming of the railways in the

1840s, which slowly depleted the many taverns and inns along the High Street with only The Angel remaining.

This famous hotel has had a number of distinguished guests pass through its doors including Charles Dickens, Jane Austen, Lord Nelson and the Prince Imperial of France who was killed in action during the Zulu Wars.

The Angel Hotel has a long reputation regarding its ghostly inhabitants. Upstairs in the timber-beamed bedrooms, an apparition of a soldier has been seen and in another room, a couple staying here witnessed a male figure staring back at them in a mirror although there was only the two of them present. Maybe this ghost is that of a man who tragically burned to death when a lamp caught fire in one of the rooms?

ANGEL PUB

Sutton

The Angel Inn is situated at the top of Angel Hill and was once a 'livery stable' where horses could be kept for owners on a weekly or monthly basis – it also has a reputation of being haunted.

According to a former landlord, a child's voice has been heard crying from the cellar of this Sutton pub and a man has been seen walking around outside in the early morning but whether this is a ghost or not is debatable. Doors and beer barrels also seem to move by themselves when no one is about.

ANNE BOLEYN'S WELL

Carshalton

Although now part of Greater London and engulfed by the sprawl of suburbia, my home town of Carshalton still retains a village feel in certain areas and old photographs of the High Street from the early twentieth century reveal little has changed in the intervening years. Carshalton stretches back much further in time however with artefacts discovered dating back to the Neolithic and Iron Ages. The town lay within the old Anglo Saxon division of *Wallington Hundred* and was mentioned in Domesday as 'Aultone' (there is an *Aultone Way* not far from the High Street) and administered by Goisfrid (Geoffrey) De Manderville. Early spellings of Carshalton had it written down as 'Kersaulton' and 'Creasaulton'. There has also been a church overlooking Carshalton Ponds since at least the Norman times (possibly earlier) and All Saints Church has original twelfth century stonemasonry although most of the present structure is late nineteenth century.

According to local legend Anne Boleyn, the unfortunate second wife of Henry VIII was riding through the village past All Saints Church when her horse slipped and a spring suddenly sprung from the ground. This incident must have struck a chord with the local villagers as there was even a short rhyme composed about the event:

Local folklore has built up around this ancient well but is there any truth in its stories?

> *There is a well at Carshalton,*
> *A neater one never was seen;*
> *And there's not a maid of Carshalton,*
> *But has heard of the Well of Boleyn.*
>
> *It stands near the rustic churchyard,*
> *Not far from the village green;*
> *And the villagers show with rustic pride,*
> *The quaint old well of Boleyn.*

Unfortunately, apart from no evidence to support this tale – the well is actually much older than when the alleged incident took place. Indeed the name '*Boleyn*' maybe a later play on the word '*Boulogne*'. The Counts of Boulogne owned vast lands in Carshalton in the twelfth century and there could have even been a chapel situated near the well.

ASH RECTORY

Ash

In 1938 the Rector who was living here was awoken one night claiming to have heard the sound of galloping. Upon opening his eyes he allegedly witnessed a spectral coach

along with several horses pass right through the bedroom. Whether the Rector was hallucinating after just being woken up remains to be seen but the Rectory is alleged to have been built on an old coaching road!

BAYNARDS PARK

Cranleigh

This Tudor Mansion near the town of Cranleigh is reputed to be haunted by the ghost of Sir Thomas More. More was born in 1478 and although he trained to be a lawyer, he entered the services of King Henry VIII as Speaker of the House of Commons. He pursued a number of other political positions until 1529 when More was elevated to Lord Chancellor, the most powerful governmental position in the country second only to the King himself.

More unfortunately fell from favour with Henry. He opposed the King's breakaway from Catholic Rome and refused to offer the Oath of Supremacy that recognised Henry VIII as the head of the Church of England and not the Pope. To this end, Thomas was found guilty of treason and beheaded in 1535. Following the execution, his head was placed on a spike and displayed over the gate into The City of London that faced the River Thames. It was More's daughter Margaret Roper who bribed the gatekeeper to retrieve the head and returned with it to Baynards Park for burial.

A fire destroyed the original mansion in 1979 with only its tower and gatehouse remaining although Sir Thomas More still wanders the grounds to this day – maybe still searching for his head!

BETCHWORTH CASTLE

Betchworth

Overlooking the nearby River Mole, Betchworth Castle was originally an eleventh century structure founded by Richard Fitz Gilbert but the present ruin is of a medieval fortified house built in the fourteenth century by Sir John Fitzalan. A large portion of the building was demolished in 1791 by William Fenwick to make way for a country residence and again in the nineteenth century that leaves little but a folly visible today.

Betchworth Castle is rumoured to be patrolled by a phantom black dog, a creature that makes regular appearances in the folklore of hauntings. Another ghostly figure seen (although in *human* form) is apparently that of a noble gentleman called Lord Hope. The tale goes that while he was chasing an escaping prisoner, Hope killed the man who he later discovered was his own son and he now walks the area in deep regret and shame resulting from his tragic deed.

A word of caution though, apart from the possibility of bumping into the ghost of the aforementioned Mr Hope; the ruin stands within an enclosure of a private golf course and members of the club seemed none too pleased with my being there!

BEYOND THE SENSES

North Cheam

This spiritual and psychic bookshop boasts a variety of services including private one to one clairvoyant and tarot readings. It also has a wide collection of books, new age music, tarot cards, candles, incense sticks, crystals and materials for Wicca practitioners filling the store. Owned by Alan Barnett, who is the resident medium with the *Spiral Paranormal* team; we have used this place as a base for a number of years as well as for meetings with the *Spiral* team (and for the odd glass of wine of course). The shop has hosted many event evenings with the likes of David Wells, Dr Ciaran O'Keeffe, Brian Sheppard, Val Hood, Andrew Grant, Ross Bartlett and Jenny Docherty presenting a diverse range of fascinating nights such as mediumship demonstrations, psychic art, trance mediumship and parapsychology.

Considering the amount of mediums that use the shop and with Alan being himself one, can psychic or spiritual energy (whatever you wish to call it) theoretically be drawn in here like a magnet, which lingers long after the shop closes? Many people have commented on the '*heavy atmosphere*' that remains in the Reading Room after a one to one session and also in the main shop after an evening of clairvoyance. Indeed, I myself have been in the Reading Room during a meditation session whereas my 'phone starting ringing. Nothing unusual in that you may say except it was switched off! Even feeling the ring tone vibration, I pulled the 'phone out of my pocket and sure enough – it was still switched off from earlier. People have also photographed many bright light anomalies that they say are vastly different from the standard orbs (don't get me started on them!). They of course could be light refractions, particles in the air or a camera fault but they are still very interesting images whatever your opinion.

The following account is open to your own interpretation and something that happened to Alan Barnett during a night back in 2006. In his back room of the shop and over a period of a couple of weeks, he had started sensing what can be described as a build up of energy by the back wall. This culminated in what Alan told me was '*the most incredible night since having this ability*'. Starting off slowly, energy in the form of balls of light began emanating from the wall; this became more and more intense as figures started appearing in these spheres and floated past him. Some of these '*people*' would acknowledge him while others just passed by – and some even greeted him with a '*Hello*'. The brilliance of this psychic light show was overwhelming he said and continued unabated for over four hours until 7am in the morning!

According to Alan (who has recounted this experience to me many times), it was a spectacular display of spirit energy and has no idea why he was witness to it. I have worked with Alan for a number of years and trust him to know that he does not exaggerate claims of the paranormal even with my own rational mind. I might not experience activity that he and other mediums say happen to them (I myself am as psychic as a brick!) but relationships built up over time make you understand that as far as Alan's point of view goes, for him it was very real indeed.

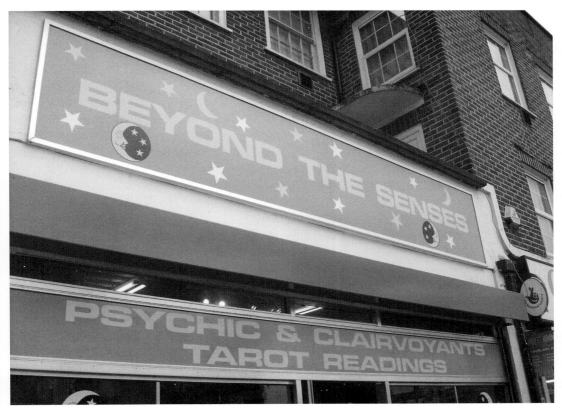

There could be more going on inside this shop than you first think?

BOOKHAM HOUSE

Bookham

Not all alleged hauntings are attributed to historic homes or old manor houses. There are many reports across the country of families living in fear from unexplained or inexplicable occurrences that seem to prevail in their homes. A great many cases can be attributed to either a psychological issue relating to individuals in the property or just from a purely overactive imagination – but can all reports be explained so rationally?

We were contacted from a lady called Jo who had recently moved into a very normal semi-detached house in Bookham. Moving in around the winter of 2009, she started feeling the sense of being watched as she went about her daily business and objects in the house were starting to be moved around. It was her partner however who experienced the most physical and visual phenomena. Not only did he have the feeling of a hand being placed very firmly on his shoulder but he actually saw the figure of an old lady standing by the back door in the kitchen! According to Jo, he is a complete sceptic but she came home one night to find him sat down in the living room, refusing to move!

I visited the house with medium Alan Barnett and fellow investigator Mandy Gibb from our *Spiral* team to see if we could uncover what was happening (if anything) in the house. Alan took himself off for a wander around the property to see what he could pick up on. After a while he emerged and explained that he was sensing two elderly people, a husband and wife with the woman the more prominent spirit. He thinks they would have lived in the house many years ago and were just looking out for the new homeowners as they were settling in. And as anyone knows who've ever moved house, there is always an overflow of boxes and items ready to be unpacked as Alan sensed the lady spirit being concerned about all the '*clutter*' about the house!

BOTLEY HILL FARMHOUSE

Warlingham

Situated in an area of outstanding natural beauty, this fifteenth century farmhouse used to serve as a tearoom which was lovingly run by Molly Fewsdale and Betty Jell for over fifty years. The ladies retired in 1990 after a half-century of service and the building fell into disrepair for three years until the present owners restored it to its former glory.

It is now a popular free house and restaurant and I would heartily recommend a meal here if you are looking for good quality food. The Farmhouse also stands on the Prime Meridian and International Date Line and this fact was authenticated by the Royal Observatory at Greenwich.

According to the Manager here, there is a grey lady who walks about this beautiful building and this was unknown to medium Alan Barnett who sensed a sad female energy here who may have lost her life in childbirth many years ago. Alan could not work out if this was a residual haunting or an active spirit though.

BOX HILL

Tadworth

A designated area of outstanding natural beauty and a place of Special Scientific Interest (SSSI) and a Special Area of Conservation (SAC), Box Hill is one of the most popular regions of the North Downs. Standing 596 ft above sea level and rising grandly over the nearby towns of Tadworth and Dorking, the Hill is named after the box trees, which can be found around the chalk cliffs cut by the River Mole. These were once very common but many were cut down in the eighteenth century as boxwood was in demand for wood graving, being the heaviest of English wood. As well as the magnificent views, the Hill also boasts a variety of butterflies and orchids.

Since the nineteenth century, Box Hill has been a popular tourist destination with walkers and cyclists visiting the Hill for its breathtaking views and stunning scenery. The inventor of the first working television system John Logie Baird, lived here for a time whilst working on early experiments. There is also an Old Fort located just

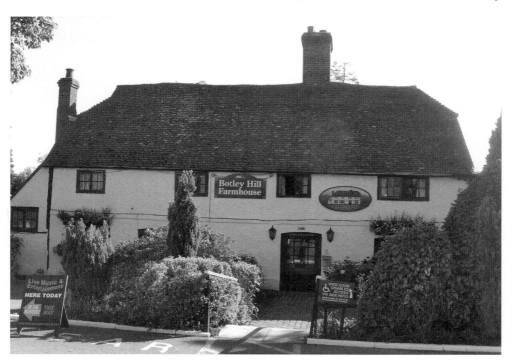

Does a grey lady wander aimlessly around this popular restaurant?

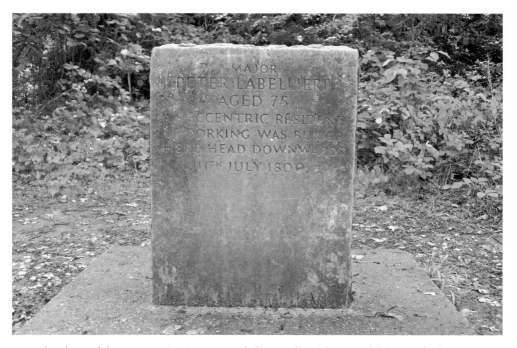

Does the ghost of the eccentric Major Peter Labellière still reside around this popular beauty spot?

This stunning view has been marvelled at for generations.

behind the National Trust shop. Built in 1899, this was used as an ammunitions store and a caretaker's lodge but is now abandoned. Since 1914, Box Hill has been owned and managed by the National Trust.

Archaeologists speculate that Box Hill may have been a sacred site in ancient times and one does feel a strange atmosphere when strolling through the woodland and heath. Various ghost stories and paranormal occurrences have been associated with the area for many years.

The prominent spirit reported here is that of Major Peter Labellière. He moved to Dorking around the 1760s and was a very religious man. Labellière was very generous and would frequently give away his clothes and shoes to the poor of the area. In later years, Labellière's appearance became unkempt and his behaviour even more eccentric and if believed, he even predicted his own death! One day out walking he tripped and fell onto a spike, gauging out an eye. When he died from this injury in 1800 (on the precise day he said he would), he was buried upside down on the Hill. Why he did this is still debated with some folklore suggesting that Labellière thought the world was topsy-turvy and when it fixed itself, he would be the right way up. Others think that he wished to be buried the same way as St. Peter, who was crucified upside down. Even to this day, there are reports of people seeing a strangely dressed one-eyed man striding through the woods or wandering around the heath of Box Hill. A gravestone now marks the spot of his burial.

At the bottom of the Hill by the river, there have been reports of Roman soldiers crossing the Stepping Stones. This phantom cavalry was seen by the author Robert Louis Stephenson who wrote about the experience in one of his poems.

BRIGHTON ROAD

Croydon

There was once a café here in Brighton Road and the building was allegedly haunted by one John Carver, a Croydon man who was charged with murdering his wife in the nineteenth century. Although many local people were convinced of his guilt, he was found not guilty of the crime but was continually hounded by the public who were convinced otherwise and Carver used the café as a hiding place before moving out of the area.

Many years later, the owner of the café reported seeing the apparition of a very tall man in grey with no head, climb the stairs and momentarily stop on the landing before vanishing. Also it was reported that strange things would occur in the building on 26 May of each year (the date of Carver's wife's death) with the sound of breaking glass and objects being moved although this account dates back to the 1940s so hard to verify.

BROOK HOUSE

Godalming

The Georgian Brook House in Mint Street has a rather sinister reputation, not least for the alleged account of a former owner of the property killing himself in one of the upper rooms. He is said to return to the place of his suicide and reported to have been seen looking out from this very room.

The apparition of a woman has also been seen and by all accounts has terrified the unfortunate people who have seen her. This phantom may have been a former resident who was killed falling down the stairs but this cannot be confirmed.

BROOKLANDS RACETRACK

Weybridge

When it opened to great pomp and ceremony in 1907, Brooklands Racetrack was the most advanced motor racing track in the world with a 2.75-mile circuit. Built by local businessman and car fanatic Hugh Locke King, the track was immensely popular with racing lasting until 1939. The area was also one of the country's first airfields and although a shadow of its former self, Brooklands today boasts an impressive aviation and motoring museum.

The prominent apparition seen here is believed to that of Percy Edwards. Percy was world speed record holder and had already been the first person to travel at 100mph. It was his second attempt in the 1920s however that he was tragically killed on the

circuit trying to beat a rival. Dressed in black leathers and goggles reminiscent of the drivers of the time, the ghost is seen in a transparent car racing around the track near to where he was killed.

The main gate is also allegedly supposed to open by itself and a thundering sound is heard from the clubhouse. During bad weather back in the 1930s, a plane crashed here and can still be heard as it struggles to land on the old runway.

BROUGHTON HALL

Send
Now a care home for elderly residents, Broughton Hall is allegedly haunted by the ghost of an old man who walks about smoking a pipe.

BUSH HOTEL

Farnham
This beautiful seventeenth century coaching inn in Farnham is now a fine hotel and retains much of its original fittings. Although a lovely setting for the modern visitor, it could also harbour the building's previous inhabitants with accounts of a servant girl being seen walking about the corridors who is said to have a very pleasing nature. Maybe she is eager for you to have a pleasant stay here!

CAREW MANOR

Beddington
Carew Manor stands proudly in the vast grounds of Beddington Park, once a Royal hunting area with the original structure being built around the mid forteenth century (formerly know as *Beddington Park House*). Related to the Carews of Pembrokeshire, the Manor was once the countryseat of this prominent family in Tudor times and a dynasty that would dominate the area for centuries. Indeed, in its heyday the Manor was graced by a number of royal visitors including Henry VIII, James I and most prominently Queen Elizabeth I.

By 1709 however, the estate had become run down and although lacking the wealth of his ancestors, the owner Nicholas Carew had the house rebuilt. Two deep wings were added but soon after the building work was complete, the north wing was gutted by fire and the whole interior destroyed. This part of the house remained in disrepair for many years and was still largely empty in 1859 when Carew Manor was converted into an orphanage; operating from 1866 until 1939. There are also underground tunnels around the area and these could be extensive however most of it was filled in during the later nineteenth century. Although there have been many alterations over the years, the roof of the late-medieval hammer-beamed Great Hall dates from around

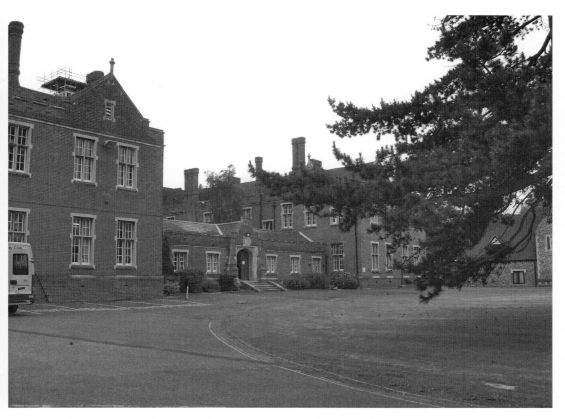

Legend has it that both Queen Elizabeth I and Sir Walter Raleigh haunt the grounds here but what really occurs at Carew Manor?

1500 and is the only Grade I listed building in the London Borough of Sutton. The Manor is now a private school.

With such a vast history, there are of course reports of spectres at the Manor and its surrounding area. The ghosts of Sir Walter Raleigh and Queen Elizabeth I are said to haunt the grounds and nearby Bunkers Lane but like many famous historical apparitions, this is more likely to be folklore than actual witness accounts. Poltergeist activity was reported in the north wing following the fire in the eighteenth century. A young girl has been heard laughing along the corridors and been seen walking across a small bridge linking the former infirmary and as well as dark shadows, a face has been seen staring out of an upper classroom window.

Ever since I was a child growing up in the area, I had listened with a macabre interest to the local stories about the Manor's ghostly going-ons. It was probably my first experience of hearing about a so-called 'haunted house' and I always wanted to explore this magnificent location, finally getting the opportunity in the summer of 2008.

A few weeks before the investigation, I visited the Manor to interview staff members and gather statements concerning their experiences at the property and what former

The labyrinth of tunnels underneath Carew Manor could be extensive and maybe hold their own secrets.

employees had witnessed. This information was not available on the internet or anywhere else and I was keen of course to keep the data under wraps from our mediums on the night. Carew Manor has never been investigated before and to maximise the time here, I invited fellow paranormal investigator Damien O'Dell (author of fine books on haunted Bedfordshire and Hertfordshire) and his team at APIS (*Anglia Paranormal Investigation Society*) along with psychic mediums Alan Barnett, Paul Cissell, Andrew Grant and Norie Miles of *Out There Media* for a night at this historic and magnificent building.

The mediumship reading of the location was very interesting with information seemingly corresponding with my reports. This included them picking up on the fire in the north wing, a girl running across a gangway by the infirmary, the spirit of a former caretaker and a woman walking along the main corridor. In the Great Hall for instance, the mediums all sensed what appeared to be dark masses of energy silently watching from the shadows but could not identify who or what they were. We had DVR cameras set up and reviewing the footage a few days later, there seemed to be an object pass by the camera in the hallway. Analysing the video, it is likely an insect such as a moth for example as it is reflecting off the infrared beam.

With APIS exploring the attic area, I took the rest of the team into a classroom where a dark figure has been seen on numerous occasions. Medium Andrew Grant however starting sensing not the ghosts and spectres of the classroom but the other mediums own spirit guides…even picking up on one of mine!!!

As the evening progressed, we gathered the whole team together in the former infirmary to hold a communication circle (séance) whilst I took Alan and Norie to a walkway linking the school to the former hospital. With eyewitness reports of a female energy moving across this walkway, Norie sensed the presence of a young girl as well as the graves of females in the nearby Churchyard of St Mary's (*see separate entry*) who died from an epidemic when the school was an orphanage. It was during this time in the early hours that Andrew started channelling one of his spirit guides through his own body. This is known as trance mediumship and is one of the many forms of clairvoyance that can be allegedly achieved. The spirit guide who channels through Andrew in this manner is from the nineteenth century and called Samuel, a charming and enlightened Victorian gentleman. I have witnessed this trance many times in the past and know Andrew well enough to make me at least scratch my head when watching him do a full two-hour, non-stop channelling demonstration. Trance is a very controversial aspect of mediumship but do try and seek out a good demonstration of this and judge for yourselves.

Rounding off the night (it was now 5.00am in the morning!); we headed upstairs to the computer room. Alan was starting to sense the presence of children here and this was confirmed by the caretaker who said other people had reported this too. To try and invoke communication, Alan started calling out and almost immediately there was rapping on one of the windows. This continued for a while and the rapping did seem to correspond with Alan's calling out although at the time, I was monitoring the room for plausible explanations and could only conclude the window tapping was the early morning breeze.

The visit to Carew Manor had been very interesting with the mediums identifying a lot of the history and events surrounding the property and to clarify, they had no prior knowledge of the location. With such a vast location to cover, we feel we had only scratched the surface with regards to its paranormal activity but it was still a privilege to be able to explore this magnificent building.

CARSHALTON WATER TOWER

Carshalton

In the grounds of St Philomena's Girls' School stands the Grade II listed Carshalton Water Tower. Built in the early eighteenth century, the 130 ft structure contained a water-powered pump that supplied water to Carshalton House and the fountains in the gardens. The Tower however also contains a number of rooms and a beautiful eighteenth-century bathroom.

The ghost of a Nun has been seen here walking about the Tower and whenever I was driven past here as a boy, I would always take a look up just to see if any spectral

Does a nun still walk around this eighteenth-century water tower?

entity would be looking back – unfortunately it never did! According to old reports as well, a Royal Messenger and a Taxman have both lost their lives on the stairway at Carshalton House and still haunt this area of the building.

CENTURY CINEMA

Cheam
Just on the north corner of Kingsway Road and Station Way and where Century House now stands was once the site of Century Cinema. It was built in 1937 with a capacity of 1,000 seats and operated until 1960 although the auditorium remained undeveloped for another thirty years.

Staff who worked here have heard feet shuffling across the stage area and thought the cinema had intruders only to find no one there.

CHALDON CHURCH

Chaldon

This beautiful and isolated church is of Saxon origin and was recorded in the Charter of Frithwald in AD 727. This very ancient structure is famous for the medieval wall painting depicting '*The Ladder of Salvation of the Human Soul and Purgatory and Hell*'. Dating from around the 1170s it was discovered during redecorating at the church in the mid nineteenth century and thought to have been painted by a Norman monk. It measures 5 metres in width and 3 metres in height and is one of the earliest and best-preserved wall paintings of this type in all of Europe.

Apart from the magnificent mural, Chaldon Church is also reputed to be a very haunted place. In the graveyard a few years ago, a photograph was taken which shows what looks like a man leaning over a gravestone although no one was there at the time other than the photographer and his friend.

CHEAM HOUSE

Cheam

In my work investigating claims of alleged haunted houses, I have sometimes found that it might not actually be within the bricks and mortar that are causing the

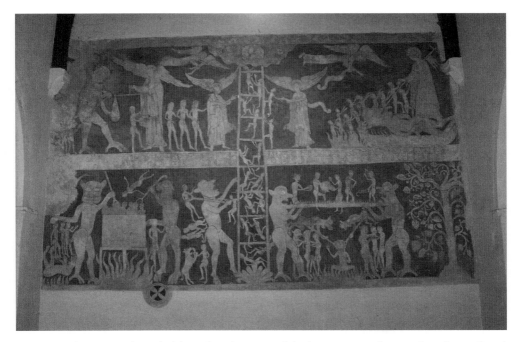

The magnificent mural at Chaldon Church is one of the best preserved examples of a medieval wall painting in all of Europe.

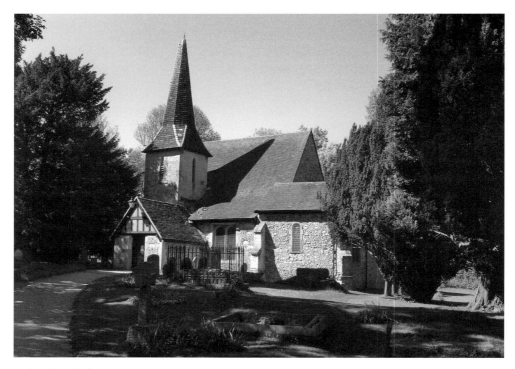

Did a ghostly figure in the graveyard appear in a visitor's photograph?

disturbances but something entirely different. This following investigation took place in the summer of 2008 when I was contacted by a lady who we shall call '*Susan*' who was very concerned about odd goings on in her new house.

About a week beforehand, I arranged to interview both herself and her son and see if there was any connection from their accounts. Susan explained all the odd occurrences that seem to be happening here including knocks, objects being moved and a strong sense of presence in the upper bedrooms (where one of the previous tenants also had some experiences). Susan explained that these occurrences also happened at her old house.

The night started with the team meeting the tenants and owners of the house whose hospitality was second to none. Although we were made to feel very welcome I did sense an obvious feeling of anxiety about the evening ahead. There is not much known about the house and it is a standard semi-detached just off Cheam village.

We initially split into two teams with one group downstairs in the living room and the others all upstairs with medium Alan Barnett. I started calling out in the living room and taking some still shots. By this point I had all ready set up a locked off camcorder in one corner of the room. All seemed quiet for quite a while until we decided to move into the hallway. Once again, I locked off the camera facing up the stairs and apart from some shadows passing by the front door (which could have easily been people in the street) we had nothing.

Someone decided to try an '*ohm*' mantra to see if the vibrations would shift. To some people this might sound very amusing (including us!) but all things are worth trying. We all sat quietly as a long winded '*ohm*' echoed about the room but we were all startled to distinctly hear a second '*ohm*' repeated back to us. At this point I naturally asked the other team if they had made an '*ohm*' sound back, but no one had. This was quite peculiar and I haven't yet found a plausible answer to the echo.

After a break, we returned to do a séance in the living room. I was operating the camera while the rest of the team performed the séance although there was nothing significant to report. We all decided to go upstairs to the room where we had all heard the '*ohm*' sound earlier. We sat on a large iron bed as I started to call out for taps, bangs etc – at this point we all heard a knock on one end of the bed but it could have been down to someone just moving. But it was a short time later when everyone jumped at the sound of a large crash that seemed to come from the corner of the room! Nothing had fallen off any of the shelves and investigating further we could not locate any form of disturbance (we had the sound captured on video too).

It was a few weeks later when Susan contacted us again and said that activity was still persistent in her house. What we later found out (or rather the mediums did) was that the energy wasn't from the house – but from Susan herself. It seems that without realising it, she is psychic herself or and at least in possible denial of what was happening to her. Indeed, on other occasions when we have met Susan socially, she seemed a little more comfortable with this ability and more '*open*' to whatever psychic forces are around. Whether you believe in psychic phenomena or not and as I mentioned earlier, it's not always the bricks and mortar that is the source of alleged phenomena.

CHERTSEY ABBEY

Chertsey
Chertsey is a place that stretches far back in time and is the earliest recorded town in Surrey with the Benedictine Monastery being founded here in AD 666. The Abbey itself was founded by future Bishop of London Saint Erkenwald and he also became the first Abbot. In the ninth century it was attacked and sacked by the invading Danes (*see Leigh Hill entry*) during their vicious campaign towards Winchester. In the late medieval period, the Abbey became famous as the burial place of King Henry V although Saint Beocca was also laid to rest here in AD 870. Vikings in around AD 871 sacked the Abbey where upon ninety monks were brutally killed and all were canonised, remembered on 10 April each year.

One of the Abbey's bells was cast in around 1380 by a Wokingham foundry and is still in use today at St Peter's Church nearby, making it one of the oldest bells in the county. Like other monastic buildings at the time, Henry VIII dissolved it in 1537 during the Dissolution of the Monasteries (*see Waverley Abbey and Newark Priory entries*).

Although the Abbey is long gone, there are many unexplained tales that continue to occur around the High Street and area of the Abbey. At The King's Head for example,

a monk has been seen in one of the bedrooms and it was reported that he had a rather smelly odour. The George Inn along Guildford Street has a haunted bedroom where a couple staying in the 1960s. They claimed that a heavy presence was in the room with them, even putting pressure on the bed itself before leaving through a window saying *'The bed seemed to go down in the middle'*. Reoccurring sounds of creaks, footsteps and murmuring have also been heard here but could this be just down to the ambience of an ancient building?

CHINHURST WOODS

Bramley
Near the village of Bramley is a crossroads by ancient woodland and there are tales of a female phantom and her old horse who haunt this area.

CLANDON PARK

West Clandon
Built by the Italian architect Giacomo Leoni for Lord Onslow in the 1720s, Clandon Park is one of the finest examples of a Marble Hall in England and the property has been much restored since being acquired by the National Trust in 1956. Indeed, two years restoration cost £200,000 to return it to its eighteenth century prime. The magnificent gardens were designed by the famous landscaper Lancelot 'Capability' Brown in the 1770s and have remained unchanged since being originally laid out. The house also boasts fine collections of eighteenth century porcelain, furniture and textiles and there are servant's books from the late nineteenth century detailing staff issues and household matters.

A dark male figure has been reported around the house from time to time and outside in the grounds, an apparition of a White Lady has been seen. This woman is thought to be a lady who had mental health issues and was the wife of one of Clandon's former owners. She was once seen by at least twenty people running across the grounds in a frenzied state but vanished as she reached a wall.

COBHAM PARK

Cobham
The house formerly known as Down Place was once home to Field Marshall Louis Ligonier. Born in 1680, he achieved an incredible career in the military fighting in many major campaigns during the eighteenth century and was finally promoted to the position of Commander-in-Chief of the British Army in 1757.

A career like Ligonier's would be impressive enough but it was for his private life that he gained notoriety. Always putting his career first, Ligonier never married but

he did engage in a string of affairs and was well known for his liking of younger girls. He held wild parties at Cobham Park well into his later life and many of his female conquests came to live there along with their illegitimate children. Ligonier died in 1770 at the ripe old age of eighty-nine and by all accounts was still getting his wicked way right up until the end.

It is said that the ghost of Ligonier still wanders round Cobham Park and the surrounding lanes, resplendent in his military uniform – and maybe he's still on the lookout for further female companionship? Also in the surrounding area there is said to be the ghost of a hermit who once made this open land his home and still walks about the parkland.

THE COTTAGES

Caterham
Deep in the heart of Surrey is located a small farm and on this farm are two cottages that date back to the 1600s. To look at them now it would be hard to believe that anyone could have lived in them as recently as the early 1980s. Time has taken its toll and having most of the glass in the window broken has not helped matters. The paint is peeling off the walls, the walls and ceilings are crumbling and the floorboards and stairs in some parts are rotten to the point of breaking away in your hands when touched. All is not lost though as one of the cottages is in reasonably good shape and perfect for paranormal investigations! Both Cottages had begun renovation in the early 1980s but work had to stop due to council intervention and they have not been touched since. Most of the original doors and fire places are still intact so you can get a rough idea of what they could have looked like all those years ago.

There are two cottages that are about 600 metres from the main farmhouse. One is called Flint Cottage and the other is Shepherd's Cottage. Both these dwellings are reported to be haunted and the only people who know this are the farmer and the few people who have lived at this location. It certainly isn't local knowledge. Back in the 1970s it is known that the cottages were lived in and it has been reported that both cottages had paranormal activity.

Flint Cottage is the most derelict out of the two and every time my friend Andrew West of *Surrey Paranormal* has been there he has reported very little activity. Even the mediums he took along didn't come up with much but reports from the tenants say different. For a period of time in the 1970s workmen lived in the cottage and they were constantly moaning about their tools that would either be moved or go missing entirely. Another story is of a French lad who stayed at the cottage for four months. He would have stayed longer but he had to leave as he was constantly being pestered by a young girl who used to stroke his hair on a regular basis. He also said that he saw the girl which motivated him to go home. It is also said that the young lad went into the cottage with dark hair but left with grey hair!

Surrey Paranormal's most recent investigation at the cottages had the mediums pick up on a young fourteen-year-old girl called 'Amy' who died of septicaemia from a cut

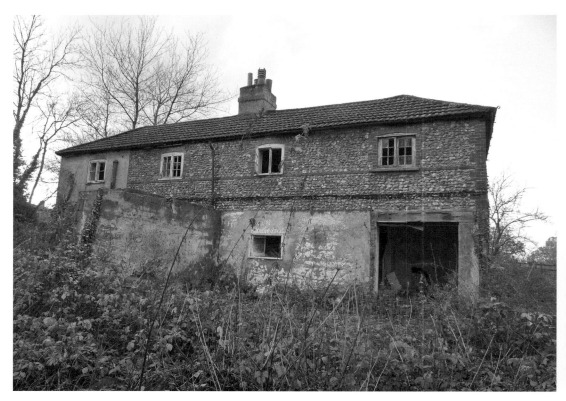

Do these derelict buildings still have the spirits of its former residents?

while chopping wood. Could this have been the same girl who was stroking the French boy's hair? The mediums also picked up on Irish travellers who broke into the cottage before the current owner moved in. They apparently used to play records backwards and were into the dark arts in a small way. The current farmer remembers having to evict some travellers back in 1968 when he moved in.

Shepherd's Cottage is in pretty good shape and is ideal as a base for *Surrey Paranormal's* own investigations but has also an interesting history of its own. The reason it's called Shepherd's Cottage is because of a former tenant who was a shepherd back in the late 1600s and early 1700s. The story is that this shepherd went to check on his flock of sheep as there was heavy snow that night and the sheep were in a field that was much like a valley with steep sides. When he got to the flock he found them buried under the snow after much digging at the bottom of the valley. They had all died which meant that the shepherd had lost everything as they were his livelihood. Tragically sometime after this, it is said that he hung himself in the upstairs bedroom in the cottage and his daughter had to cut him down. There is no mention of a wife or any other family members.

Mediums at different investigations have picked up on a small boy at the cottage and radio chatter has been heard from a stricken aircraft during the Second World War.

There is a small airfield nearby that was used during the Second World War. Other reports from the mediums are of someone dying from childbirth in one of the rooms and also some sort of rituals has been performed in the same bedroom. Mediums have stated that on one wall was a pentagon and on the opposite wall was an inverted cross.

Andrew West was very lucky to be contacted by someone who lived at Shepherd's Cottage from 1972 to 1978. Carol and her son came up to the location for an investigation with Andrew and his team at *Surrey Paranormal*, which was the first time she has seen the house since leaving in 1978. Her husband worked on the farm and the family lived in the cottage. Just to add to the drama it was just before Christmas 2009 which saw heavy snow on the night of the investigation – which was quite apt Andrew thought!

Carol said that things would be moved or go missing only to turn up in a random place a few hours or days later. She reported that she saw and heard someone walking around the cottage on a regular basis only to find no one there. Two separate mediums on separate investigations have said that there is someone who walks around the cottage protecting the occupants from some other entity! She also claimed that after putting the children to bed she would come down the stairs and sit to watch the television at around 7pm and a loud bang would be heard on the living room door. This happened almost every night while she was living there. Andrew and his team have tried to replicate this phenomenon but unfortunately to no avail.

During *Surrey Paranormal's* first investigation at this cottage the team could smell the stale stench of alcohol in one of the rooms. Andrew described it 'like you were talking to an alcoholic who spent his life in the pub'. Also while this odour was in the air a few of the team could see little dots of red light moving about the room. Andrew witnessed one of these red lights float from the cameraman's right eye up and away from his head for about 2-3 inches. This same phenomenon occurred at Flint Cottage the same evening. While in one room Andrew also saw faint little balls of light dance at the opposite end of the room then a golf ball sized ball of light floated from the room and out of the door!

The whole site seems to be steeped in history and it's not just the cottages that seem to be haunted. The farmhouse itself has many spirits residing in and around the property. The garden has a very old tree where hooded figures have been seen as well as a man with a sheep dog that has been seen by different people at different times. All the mediums who have entered the garden have all been drawn instantly to the tree and two different mediums on separate investigations have said that someone was hung from the tree in some sort of ritual. Other mediums have come up with former residents that have been confirmed by the current owner and also other bits of information about the land and buildings former usage have been successfully confirmed by the owner and research done by *Surrey Paranormal*.

This little bit of Surrey is not only steeped in history but is busy with spirits who are not famous in any way unlike most haunted locations. This alone makes it a most interesting place to investigate and every time we go there we come up with another story to keep us busy.

THE CROWN INN

Oxted

This charming pub in Oxted is said to be haunted by a former landlady who walks along an upstairs corridor of her former work place late at night. There are also reports of a man (possibly an old regular at the pub) who sits by the fireplace.

CROYDON AIRPORT

Croydon

Most of the area that was the former Croydon Airport is now occupied by open fields and the Roundshaw Housing Estate with surrounding buildings now a hotel, offices and an industrial estate. In its heyday, the airport could boast many historic flights including those of the famous airwoman Amy Johnson. Although nowadays it has a modern makeover, it never forgets its historical aviation heritage.

For many years the site around the Airport has had reports of paranormal phenomena especially within the Roundshaw Housing Estate. There are old accounts of a phantom motorcyclist seen dressed in Second World War clothing. There's also reports of three nuns who roam the streets and even appeared in a front room of a home prompting the startled owners to move house. These phantom nuns may be the apparitions of Mother Superior, Eugen Jousselot and Sisters Helen Lester and Eugene Martin of the Congregation des Filles de la Sagasse. They were killed when a Spencer Airways Dakota plane crashed in a snowstorm in January 1947 when it collided with another aircraft on its way back to Czechoslovakia (now Czech Republic). They were said to appear where the old runway and aerodrome were situated. Other reported phenomena includes the sound of singing from the Boiler House that supplies power for the estate and a ghostly male figure has been seen that could be that of a pilot killed back in the 1940s.

In 1968, residents may have had the unexpected experience of witnessing a *unicorn* (yes, you read that right) galloping across an open field near the estate – this was nothing supernatural however as it was a BBC film crew shooting a short sequence for the Patrick Troughton *Doctor Who* story *The Mind Robber!*

DEVIL'S PUNCHBOWL

Hindhead

Beside a deserted road amongst the heath land of Hindhead stands a commemorative stone marking the site of a brutal murder that occurred in September 1786. A young sailor (his name is unknown) was returning home to Portsmouth and stopped by The Red Lion Pub in Thursley for refreshments. He befriended three other sailors by the names of Michael Casey, Edward Lonegan and James Marshall and they too were on their way to Portsmouth but were down on their luck, penniless and unemployed.

The unknown sailor took pity on the men and paid for their food and drinks and raised their spirits during an evening of merriment and decided to join them on their way along the old Portsmouth Road. Unfortunately this was to be a short lived journey; the three men savagely attacked and brutally murdered the sailor along a deserted stretch of Hindhead Hill. Thursley villagers however witnessed this ghastly deed and the three killers were pursued to an Inn at Petersfield and arrested. They were tried at the assizes in Kingston and sentenced to death by hanging on 17 April 1787. After the execution the bodies were soaked in tar for preservation and placed in gibbets for all to see; a deterrent to those wishing to break the law whilst the unknown sailor was buried in Thursley Church.

There are legends that the spirit of the unknown sailor still haunts this windswept and desolate area and by the commemorative stone, local folklore says no grass or wildflowers will grow there.

DOGHURST

Limpsfield
Located near the Surrey and Kent border, Doghurst House is a Grade II listed timber-framed building of possible fifteenth century origin. This two-storey building was extended with brick and stone in both the sixteenth and nineteenth centuries and once again in 1920. There are extensive grounds attached to the house, having been used as a working farm for many years.

A friend of mine called Al (who is part of the *Spiral Paranormal* team) used to visit the house as a child during the summer holidays when his uncle was the groundskeeper. He had heard stories about an odd presence around the building especially on the stairway which he used to avoid as a child.

Our team consisted *Spiral* members Al, Annalisa, Sara, Kat and myself and upon arrival, we introduced ourselves to the owner who said we could have full run of the downstairs and the grounds. This place is was incredible and even on a warm summer's evening, you could still get a feeling of the many stories this ancient house has stored within its walls.

We set up the crew room in the kitchen and decided to keep ourselves to the ground floor of the house as not to disturb the owner who was upstairs in bed (having an early start in the morning). We went for a walk in the grounds to start off with so that the team could get their bearings. The grounds were extensive and on this warm night, we felt that it was one of the most picturesque places we had visited. There is a gypsy caravan in the garden which remarkably was picked up on by a remote psychic reading of the property a few days prior to us visiting here.

Returning to the crew room I filmed a few interviews for the video before deciding to begin the investigation in the children's playroom just along from the kitchen. We tried a number of different methods here including using dowsing rods, recording EVP (Electronic Voice Phenomena) and asking out for responses. Nothing much happened here although we were trying different techniques so we moved onto the oldest part

This old house may still have many secrets to reveal?

Who else will be joining us for dinner at Doghurst?

of the house which dates back to 1425 and is now a dining room. I set up a locked off camera and we all sat a large table in the centre of the room and began calling out whilst taking still shots but still nothing (which is fine, paranormal investigation is a patient process!)

After a while, we moved into the hallway entrance where the front door now stands (it was originally somewhere else). This room dates from 1465 and has a large open fire place and every thing leads off of this room as well as the stairs to the next floor. It was here as a child that Al had the feeling of being watched from the stairs but as with all the other rooms nothing happened. In all our investigations – if we get nothing, we show nothing in our videos. Investigators can sometimes be too quick to think potential evidence is paranormal without analysing the data more. Even if you are left with something unexplained after critical analysis, it still does not mean it's paranormal.

We ventured out into the grounds and I decided to use dowsing rods once again as a tool. Dowsing is an ancient practice that theoretically channels energy through the body as a conductor into the rods. This art has been used for water divining and locating earth energy but some use it for communication with spirit. I was standing still when the rods began rotating very rapidly although I was not moving at all and the air was still. This occurred a couple of times and to make sure no subconscious human error was involved, I stood dead still with the rods pointing forward with no momentum. It happened once again although there is no apparent reason as to why it did this.

Doghurst with its fine house and grounds was a very impressive location although little activity was forthcoming contrary to previous reports. As this place had never been investigated before, maybe the spirits were wondering what was going on? Doghurst is one of the most beautiful properties I have visited and the house really is a hidden gem in the Surrey landscape.

DUNSFOLD AERODROME

Cranleigh
Being a long time James Bond fan I found this following account quite intriguing. During filming of the recent Daniel Craig 007 movie *Casino Royale*, the crew reported seeing an apparition of a woman walking along the aisle of a Boeing 747 that was being used as a set.

No one really knows who this woman could be but speculation suggests it was the ghost of a passenger who had died of a heart attack over thirty years earlier.

EASHING BRIDGE

Godalming
Constructed by Monks from the nearby Waverley Abbey (*see separate entry*) in the thirteenth century, this ancient double bridge over the River Wey is still crossed at night by those medieval builders of long ago.

EPSOM HOUSE

Epsom

Just like Cheam House (*see separate entry*), I was called in to help with a situation at a private house in Epsom where an alleged unseen presence and some strange activity had been affecting the owner's family. To protect identities, I shall refer to the owner only as '*Jane*' who had told me that since moving into the house back in 2002, her daughter had sensed a presence in her bedroom and she herself had experienced physical pressure upon her body that was very distressing as well as a strong negative presence in the building. Jane felt most uncomfortable in the garage area which is now located through the kitchen as the front is blocked up. When things started becoming out of control in 2006, she brought in a local medium to see what could be done but the unexplainable events continued to occur with regular banging and things being moved. Whether this was either a purely physiological situation or possible paranormal activity, I felt an obligation to try and help Jane with medium Alan Barnett on hand along with the *Spiral Paranormal* team to see what may be residing in this house.

On the night of the investigation, Alan took time out alone in the garage to condition him for the evening. He told me afterwards that he too had felt a pressure against his stomach and would hopefully be able to reveal more information as the night progressed.

With the team in place, the garage seemed a good place to start as this was an area that Jane had been most uncomfortable with. As mentioned before, physiological or psychological reasons for her experiences could be at play here but one needs an open mind to other possibilities as well as the obvious (and my preferred) rational viewpoint. Our sound expert Duncan also set up audio recording equipment using shotgun microphones connected through a laptop to hopefully capture any possible EVP (Electronic Voice Phenomena). We settled into the area and I had various people call out in the hope of some feedback from whatever (if anything) was there other than us. After a while some people seemed to be sensing a heavy atmosphere here with Alan starting to pick up on a woman. At this point as well, Jane started feeling unwell and surprised us all by leaving the area almost in tears. I followed her out and though still clearly upset, she told me that she had felt a tight pressure against her throat as though something was forcing to crook her head back. Back in the garage Alan was now seemingly sensing a woman much clearer who seemed to have taken her own life back in around the 1950s. As before when he came here on his own, Alan also felt a strong pressure around his stomach and a sharp pain across his wrist.

After a while we moved the team upstairs to Jane's daughter's bedroom. It was here that Alan started picking up on a man who wanted us to leave as well as something was touching his face (wouldn't it be nice for once for spirit to actually want people too stay!). The woman who Alan picked up on in the garage was also popping back in and he had a mental image of a lady with long black hair. We turned our attention to Jane's bedroom where a lot of activity had been reported. It was here that Jane explained that her portable CD player never works for long as the batteries drain very

What unknown energies disturb a family in this Epsom house?

quickly. This of course, could be nothing more than just a faulty piece of equipment but I took this information on board.

Alan and Jane sat on the bed and she explained more of the phenomena that she experiences here. She pointed out that she usually sleeps downstairs for part of the night having been affected in the past by a pressure on her rib cage. As she was talking however, we all heard an unexplained sound by the door and upon checking this out could not find what it was (although I doubt it was anything paranormal!). Alan was now beginning to get a clearer picture of the alleged spirits in the house. He said that he was picking up on a male who seemed to be the violent husband of the woman. He added that the man prevents this lady from doing what she wishes and he had tragically contributed to her suicide adding dialogue he was sensing – '*she won't leave until he leaves*'!

With all electrical appliances unplugged in the room, there was a strong EMF reading (Electro Magnetic Field) around Jane (as had happened at *The Old Rectory – see separate entry*). The EMF meter was registering a very high output that was almost ridiculous and we all wanted to test the validity of the equipment. We plugged in the only electrical appliance (a lamp) and when switched on, the meter registered

as normal and nothing when unplugged again. As Jane felt something touch her head, the meter kicked in again. One of the team fetched a second EMF reader but bizarrely, this registered nothing except when doing the electrical tests on appliances. Surely they should both be picking up the same readings? Interestingly, the first meter reading would at one point detect nothing and then on a second attempt would register an EMF flux.

We took a break for a while which gave us pause for thought on the evening so far. One of the ladies from the team approached me and mentioned that she had a slight scar on her left wrist that was not there before (similar to Alan's pressure on his wrist earlier in the garage). This was a fresh cut and she had not been near any sharp objects that she could recall during the investigation up to that point. While everyone relaxed, Duncan set up once again an enhanced audio microphone in the garage which fed through to a PC laptop. He set the recording going, securing the garage from any external interference as we resumed the investigation in the front living room. As we all settled into the environment, Alan once again felt the spirit of the man right up against his face! Ben also felt cold (which is unusual as he works outdoors and rarely feels a chill). It was at this point that we decided it might be a good idea for the girls to do a lone vigil without us to try and coax this male energy forward. On this occasion, we did not give the girls a camera but Jane said to me afterwards that they heard a tapping sound from the area around the television – and an alleged *groan!*

Our last location to investigate was the spare room. We tried something that we don't usually entertain a lot which is glass divination. We attempted this with the girls only and once again, the EMF meter registered high readings but nothing moved on the board. Both Alan and myself used a crystal for a reaction to alleged spirit in the room, which proved more successful. I personally find glass divination prone to human error, either sub-consciously or lack of focus. I always recommend placing only finger nails on the glass (which can get uncomfortable after a while unfortunately) as this vastly reduces any potential human error.

As the evening drew to a close, I was interested to see if any immediate EVP recording was apparent ahead of a proper analysis later. Duncan was already reviewing the audio data and was unsure of what was captured on the sound track. Listening closely, it sounded like a single tapping noise that was intermittent during the thirty-minute recording. Although no one was in the vicinity, we don't believe it was anything paranormal but we were still open minded about it could be.

The investigation at Epsom House had proved more interesting than we originally thought with certain members of the crew had become emotional during the evening. A scar suddenly appearing on someone's wrist and various other phenomena made it a worthwhile evening and hopefully we gave Jane a piece of mind that would help her. Some spiritual friends who were there that evening thought it would be a good idea to do a clearance (which is allegedly moving trapped spirits into the light). Although I am not convinced whatsoever that this can done or that we have any influence on spirit, Jane was happy for it to be done so a ritual was performed to achieve this.

Indeed, a few days later Alan spoke to her and she was much happier in her home. The negative atmosphere seemed to have vanished and the ambience of the house had

returned to normal. Whether our investigation had a psychological effect on Jane that convinced her that the energy in the property had dispersed is open to debate but the important thing here is that her and her kids felt much safer and comfortable and this should be the main reason for helping in the first place.

HIGH STREET

Ewell
Although Ewell is yet another Surrey village that has been engulfed by the suburbia of Greater London, it still harbours some ancient buildings and apart from the constant traffic; has maintained a quaint rural feel to its High Street.

There are tales and stories of several phantoms that haunt this area including the hoofs and rattling of a coach and horses outside the William IV Inn and a male figure that resides by the old village Goal. One of the houses that dates back to the sixteenth century is allegedly haunted by a female spirit called '*Agnes*' and the nearby churchyard of St Mary the Virgin has a plague pit of unfortunate children who were victims of the tragic pandemic from centuries ago and are said to haunt this plot where they were buried.

FAIRLAWNS

Woodmansterne
This house in Woodmansterne must be a busy place for ghosts as three separate phantoms have been reported here. Wearing what has been described as medieval garments, a woman and two men have been seen around the property with them wandering along the corridors as well as tapping on the walls. In 1948, a series of séances were conducted and no more reports of the ghosts have been heard of since.

FARLEIGH ROAD

Warlingham
A tall man was seen crossing this road in 2009. He looked slightly transparent and vanished as he walked into a thick hedgerow.

FARNHAM CASTLE

Farnham
Built by Henry de Blois, Bishop of Winchester in the twelfth century, Farnham Castle stands proudly over the historic town of Farnham and has been an important part in the life of this parish for many centuries. For over 800 years, the castle was used by

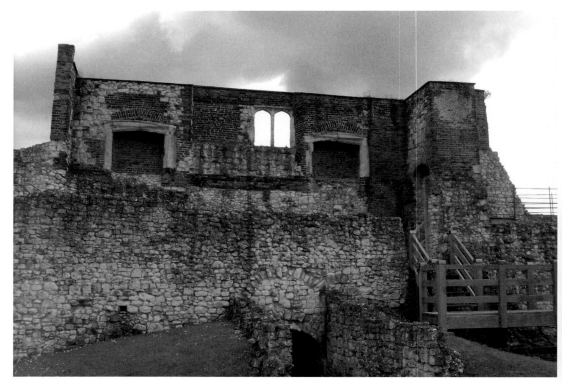

With over eighty years of history, is it any wonder Farnham Castle is said to be haunted!

the Bishops of Winchester as a home and administrative centre and the town itself witnessed more activity during the English Civil War than anywhere else in Surrey. The Bishops here often shaped English politics with nine of them becoming Lord Chancellors and this remained a residence for them up until the twentieth century. During the Civil War, Parliamentary forces attempted to capture the Castle with much of the Keep was blown up in the skirmish. This is all that really remains of the original structure although newer buildings were constructed around the Castle grounds. It is now managed by English Heritage with much of it now a Conference Centre but still well worth a visit.

Farnham Castle has much reported paranormal occurrences with the Keep the main focus. At the Keep entrance there is said to be a male figure in what looks like heavy armour patrolling here and a 'heavy atmosphere' prevails as you enter the Keep remains. There used to be a bell that was housed in the tower and this can still be heard tolling as well as a phantom monk seen who is said to be that of Bishop Morley who died in 1684 and haunts Fox's Tower. Once a heavy door flew open by itself and people believe this is to be him. Morley in life was a generous man who lived a pious life; he tried to restore the Castle after the damage caused during the Civil War and maybe it's his attachment to the Castle that he finds hard to let go.

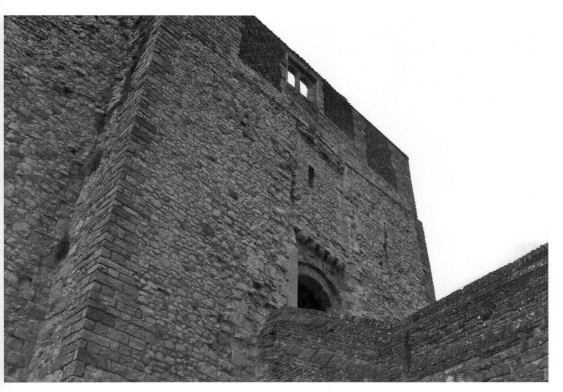

Does Bishop Morley still remain at his former residence many years after his death?

Fox's Tower also has a precession of other Monks who walk silently past here in deep prayer and in the cellar a soldier who was unfortunately shot in the face affects visitors entering here.

Disincarnate voices are heard from the Great Hall and a figure has been witnessed around the Guard Room. It is said that a girl died on one the stairways and she still remains here dancing gleefully to whoever might see her. Farnham Castle very much deserves its reputation as a haunted location with the many spirits still around to greet the unsuspected visitor!

GAUMONT CINEMA

Rosehill
Situated just off the Rosehill roundabout along Bishopford Road in Carshalton, the Gaumont Cinema once stood before transforming into a Bingo Hall in later years. The cinema was a 2,000 seated venue and constructed as part of St Helier Estate, a vast housing complex built between 1928 and 1936 on former lavender farmland which re-housed thousands of people from the decay of inner city London.

There are old accounts of a spectre in this building that would approach staff but disappear when spoken to. There was also an old organ which was removed from the cinema many years before its refurbishment and local residents often heard organ sounding music coming from inside in the early hours of the morning. A male figure has also been seen standing at the top of the stairs but vanishes if approached.

It's interesting to note that during reconstruction into the Bingo Hall, there were three tragic deaths of workmen employed on the site. One fell down a flight of stairs, a night security worker was found dead after a shift one morning and one other fell of high scaffolding and could it be these unfortunate events which have contributed to the building's mysterious occurrences?

GOLDEN GROVE INN

Chertsey
This attractive 400 year old oak-beamed coaching inn was once used by highwaymen who attacked and robbed from travellers on their way to Windsor. The ghost of an unfortunate victim killed by a local monk still haunts a room in the pub where the murder took place many centuries ago.

GREYHOUND INN

Carshalton
Directly opposite Carshalton Ponds and near Anne Boleyn's Well (*see separate entry*) stands The Greyhound Inn which was originally built in the early 1700s and has been providing refreshments for weary travellers for many years – or nowadays a good drink to relieve the stress of a busy day at work! The Inn is a listed building and carries a local heritage plaque which reads:

> *'This public house was known as the Greyhound as early as 1700. It was a sporting centre and the venue where racehorses were inspected prior to competing on Banstead Downs. The old inn was rebuilt c. 1840 and a separate existing building 'The Two Rooms' incorporated.'*

The Inn has its resident ghost of course and according to local legend, this particular phantom is of a man who froze to death at the front entrance in the early 1800s.

GUILDFORD CASTLE

Guildford
Constructed in 1086 shortly after the Norman Conquest, Guildford Castle was originally a motte and bailey structure and was built high above the town as a sign

Many apparitions have been seen around the old keep and will they have their own tales to tell?

of prominent power over the area. Like most buildings of this time it was probably erected using skilled stonemasons and labourers from the surrounding area who would have had little choice but to obey their new Norman conquerors.

In the twelfth century stone replaced the old wooden defences and as well as doubling as an administrative centre and Royal apartments, the Keep was used as the county gaol. After the forteenth century, the castle fell into a state of disrepair although various attempts were made to convert it into residences but it wasn't until 1885 that Guildford Borough Council bought the ruin and opened the castle as a park, which is how you see it today.

An apparition of a Victorian lady has been seen wandering around the grounds of the castle and may not realise she is dead. Also standing at the top of the stairway in the old Keep is a ghostly woman and a recent report concerned a child who apparently saw a man shackled to a wall which fits in with its former use as a gaol.

HAMPTON COURT

Kingston upon Thames
No tour of haunted Surrey would be complete without visiting the magnificent palace of Hampton Court. Built in 1514 by Thomas Wolsey, Archbishop of York; the building

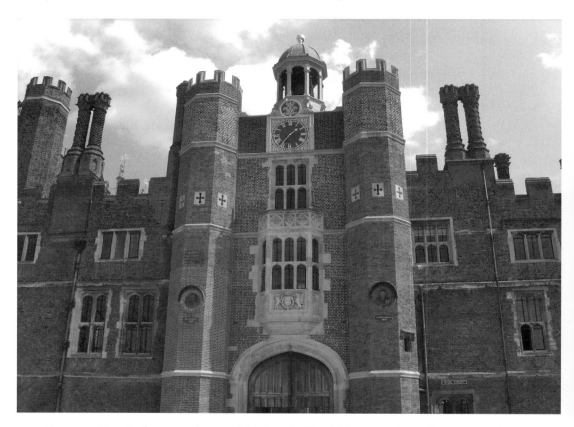

Hampton Court's close association with Henry VIII and his many wives,s has prompted many sightings around the palace.

was later acquired by Kind Henry VIII in the 1520s and his association with the building (although rather unfairly) is the most widely known. With Henry's occupancy, alterations and extensions were added with much of what we see today built and planned by him including the general lay-out of the gardens spending £62,000 on the Palace (£18 million in today's money).

Henry's infamous marriages are still a prominent feature in this grand building. Jane Seymour gave birth to the future King Edward VI here but sadly died shortly afterwards and it was here that Kathryn Howard was accused of infidelity which lead to her execution. A well-known account is of Kathryn escaping from her guards to desperately plead for her life whilst Henry prayed quietly ignoring her cries. Henry also married Katherine Parr in the Royal Chapel.

During the Civil War, Oliver Cromwell – The Lord Protector, moved into Hampton Court with his wife Elizabeth. In order to raise money for the Commonwealth, many of the Palace's fine art treasures were allowed to be bought off at absurdly low prices with Cromwell buying up much of them (including the Palace itself!) and ironically lived at the Court like a King.

Of course, Hampton Court is world famous for its ghosts and hauntings with much of it obviously centred on Henry and his wives with alleged reports of up to twenty-five phantoms here. The ghost of Kathryn Howard is alleged to roam the Long Gallery (also called the *Haunted Gallery* for this very reason) where she screams for her life to be spared and Jane Seymour is said to have been seen walking the corridors and cloisters on the anniversary of her son's birth but like other famous historical ghosts, it's more likely a romanticised view of what people would like to see!

Then there is the apparent apparition of Sybil Penn, nursemaid to Edward VI and Princess Elizabeth. She died of smallpox after contracting the disease from the young Princess who she had been nursing back to health. She was buried in Hampton Church with an effigy raised over her tomb. The church was unfortunately demolished in 1829 and according to some accounts; her tomb was disturbed resulting in some of her remains spilling out onto the floor. As a final note to this story, a few years ago an old spinning wheel was discovered in a previously unknown room at the Palace and this was claimed to belong to her – although I am not sure how this ownership could be verified?

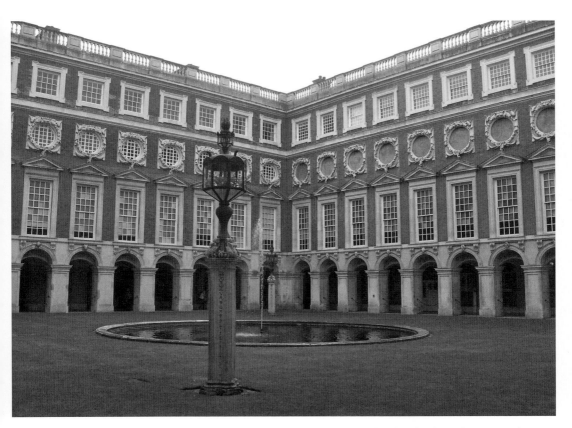

Were two bodies unearthed at Fountain Court in 1871 responsible for the disturbances in the above apartments?

Even the great architect Sir Christopher Wren gets a ghostly look in. Most famous as the designer of St Paul's Cathedral, Wren lived at Hampton Court from 1668 until 1723 and according to some; he still walks up and down the staircase of the Old Court House.

In 1871, workmen were digging for a new drainage system by Fountain Court when two skeletons were uncovered. Upon this discovery, a lady resident who lived in an apartment near the cloister said that '*the two wretched men found have been haunting me for years!*' No one had believed her before and she was convinced the skeletons belonged to the men tormenting her.

A very recent occurrence happened in October 2003. Following unexplained openings of a fire exit near Clock Court on three consecutive days, CCTV footage revealed a mysterious long-coated dark figure opening the doors on the second day. This footage circulated around the world has been analysed many times although as even staff do not use the exit although it is now believed to be a hoax!

HAM HOUSE

Richmond

Nestled next to the River Thames, Ham House in Richmond was built in 1610 for Sir Thomas Vavasour who was Marshall to King James I. William Murray later acquired the House and between 1637 and 1639 he remodeled the interior of the House creating the Great Staircase, new rooms and the Great Dining Room which is now the Hall Gallery.

Ham House has had a long line of distinguished residents including The Duke and Duchess of Lauderdale who decorated the house in grand style. The Duchess Elizabeth, herself was a rather promiscuous lady with a string of affairs including (allegedly) Oliver Cromwell. There is also the tale of her murdering her first husband so she could marry the Duke of Lauderdale. She was a patient lady however and had to wait a few years for the Duke's wife to pass away before marrying him.

After Elizabeth herself died, the house fell into disrepair. It was in 1770 that Horace Walpole, the author of *The Castle of Otranto* and who founded the Gothic architectural style wrote: '*At every step one's spirits sink. Every minute I expect to see ghosts sweeping by*'. A fitting description indeed but it should be noted that there are no reports of ghosts from this period. The National Trust bought Ham House in 1948 and with much work, restored it to its seventeenth century splendour.

But are there ghosts at Ham House? One of the earliest accounts was from Augustus Hare who visited here in 1879. Writing in *The Story of my Life* in 1900, he wrote:

'*There is a ghost at Ham. The old butler there had a little girl; she was then six years old. In the small hours of the morning, when dawn was making things clear, the child, waking up, saw a little old woman scratching with her finger against the wall close to the fireplace. She was not at all frightened at first but sat up to look at her. The noise she made in doing this caused the old woman to look round, and she came to the*

Is it the Duchess of Lauderdale that still haunts the house of grounds of Ham House?

Odd occurrences and strange tales make Ham House an intriguing place to visit.

foot of the bed and, grasping the rail, stared at the child long and fixedly. So horrible was her stare, that the child was terrified and screamed and hid her face. People ran in and the child told what she had seen. The wall was examined where she had seen the figure scratching, and concealed in it were papers which proved that in that room, Elizabeth (the former Duchess) *had murdered her first husband to marry the Duke of Lauderdale.'*

It is said that a grey lady seen is that of the Duchess who still haunts the house and grounds today. She has been witnessed wandering silently through the Italian ornate gardens and the rapping from her walking stick can be heard along the corridors of the house. Other odd happenings also occur here including a figure that climbs in through a window in the middle of the night only to promptly vanish.

For a many years Ham House has had a strong reputation regarding its ghostly inhabitants and it's not afraid to include them alongside the traditional heritage of this historic property.

HARTSFIELD MANOR

Betchworth
Built in the 1860s by Arthur Jaffray, Hartsfield Manor is a fine Victorian Mansion set within 16 acres of stunning Surrey parkland. It was a family home until the Second World War when the Canadian Army used it as a hospital. Retaining many of its original features, the Manor now serves as both a Conference Centre and Wedding venue.

But there may be other occupants still wandering around the building. In the main Dining Room there have been accounts of children playing here who are wearing what looks like Victorian or Edwardian clothing as well as a hunting dog running up the stairs and disappearing. A figure of a man has also been seen sitting at the bar and a woman with grey hair in one of the upstairs bedrooms.

HILLSIDE

Wimbledon
This residential road near Wimbledon Common has had some strange occurrences over the years and has built a reputation as the most haunted road in Wimbledon (as stated in my introduction, one is always sceptical about these sort of claims).

Appearing between 11pm and midnight, a young girl has been seen walking through a house and into the garden but slowly vanishes from sight. This same house also reported disturbed activity with cutlery flying through the air.

Other incidents reported include a man going to his parked car only to find all his music cassettes (I would assume this is in pre-CD/iPod days?) all thrown about his vehicle although the car was locked. In another house, residents were startled to find

they could not get out of an upstairs room but people on the outside could open the door with ease – I would hazard a guess however that maybe the incident is due to a faulty lock and not attributed to some troublesome spirit!

HOGS BACK

Guildford
A recent occurrence happened near Tongham Junction on the A31 that runs across the Hogs Back near Guildford. Driving home late one night in heavy rain, a driver observed a horse-drawn carriage cross the road about 100 metres ahead of him. As the car approached the spot where the carriage was seen, there appeared to be no side road or hidden entrance for the old vehicle to emerge from!

HOP BAG HOTEL

Farnham
Although demolished in the early 1990s, stories of paranormal activity at this Farnham Inn go back many years. Most prevalent was the sound of a coach and horses clattering into the courtyard in the middle of the night and a grey lady has been seen who allegedly is waiting for the return of her lover who was tragically killed nearby.

HORSELL WOODS

Woking
Seemingly gliding along in this Woking woodland is that of an apparition of a man in a raincoat and in 1994, someone reported seeing another figure (carrying a rucksack no less) walking ahead of them but with the legs cut off below the knees.

KING EDWARD VI SCHOOL

Witley
Founded in 1553 by Kind Edward, this private school is reputed to be haunted by a former pupil who was tragically killed whilst performing a tight rope act in front of his school friends. According to some, the young boy placed a broomstick across the stairwell and edged slowly along the pole when it suddenly broke. He fell several feet and clambered back up but unfortunately his injuries were severe and he died on the spot. According to accounts, the apparition of a boy around late afternoon has been seen around the stairway before slowly vanishing a few second later.

KINGS ARMS HOTEL

Goldalming

In 1698, Tsar Peter the Great of Russia stayed in this fine hotel along with an entourage of twenty guests after watching British Navy manoeuvres in the Solent. By all accounts, this party of foreign dignitaries were a rowdy bunch and caused much uproar in the town with wild partying, eating and drinking. Indeed, the girls of the village ran from the advances of these lecherous Russian visitors and from what was reported at the time, the Kings Arms was left with a hefty unpaid bill which was reportedly settled by the Royal funds! The diarist John Evelyn who owned Wooton House nearby (*see separate entry*) had been asked by the King to allow his London home at Deptford to be lodgings for the Russian entourage and this too was left in a complete mess with £150 worth of damage.

Whether that party is still in full swing or not, the King Arms Hotel has had a long history of poltergeist (meaning *noisy spirit*) activity as well as the sounds of laughter and heavy footsteps on the upper floors. In the Bar area, glasses have been known to smash and a grey figure has also been seen in an upstairs room!

Heavy footsteps and the sound of partying have been reported at this Goldalming Hotel.

LEITH HILL

Ockley

One of Surrey's earliest recorded events occurred at Leigh Hill and around Anstiebury Hillfort in AD 851. A Battle raged here as Ethelwulf of Wessex fought back the invading Danes who were aggressively heading towards Winchester after having already sacked Canterbury. Winchester was then was the capitol of Anglo-Saxon Wessex and the centre of government and had to be protected at all costs.

By all accounts, the ensuing conflict was particularly fierce with very few Danes left alive at the close of the fighting. It didn't end there though as any Danish survivors were hunted down and brutally killed. It was said that a pond by Ockley Green ran red with Danish blood and in a report from the *Anglo Saxon Chronicle* written 400 years after the battle it stated '*they* (the Danes) *were so heavily defeated that by sunset there were none left to bury their dead.*'

It's been reported too that the sound of men in battle has been heard here and although a peaceful and tranquil spot today with fantastic views of the Surrey Hills, you do get the feeling of a presence around you at certain times. At nearby Etherley Farm in the early eighteenth century, considerable human skeletons were uncovered here.

Leith Hill itself rises 965 ft above sea level and is an Area of Outstanding Natural Beauty. It is the highest place in Surrey with dramatic views over the North Downs and on a clear day you can see both St Paul's Cathedral and the English Channel. Crowning the hill majestically at its peak is Leith Tower, a 65 ft structure built by Dorking man Richard Hull in the eighteenth century. When he died in 1772, he wished to be buried underneath the tower and is still there to this day with reports of him still walking around his grand building!

LOSELEY HOUSE

Loseley

This grand Elizabethan Manor was built in the 1560s by Sir William More upon the request of Elizabeth I. William was one of a wealth of Tudor landowners who made substantial profit from the Dissolution of the Monasteries and plundered stone from the recently dissolved Waverley Abbey nearby. The Manor has been the countryseat of the More-Molyneux family for over 500 years and is set in stunning parkland just south of Guildford.

With such a long history with the house and its continued occupancy, there are many tales of the ghosts who reside here. For example, there is a female phantom with a pleasing nature that was seen by an owner of the house. He later found a portrait of her in the attic and thought she may have lived there once.

There is also an intriguing tale of a lady dressed in brown and a story associated with this female phantom from over 400 years ago. The tale goes that this lady murdered her stepson so her own son could inherit her husband's fortune. The husband however,

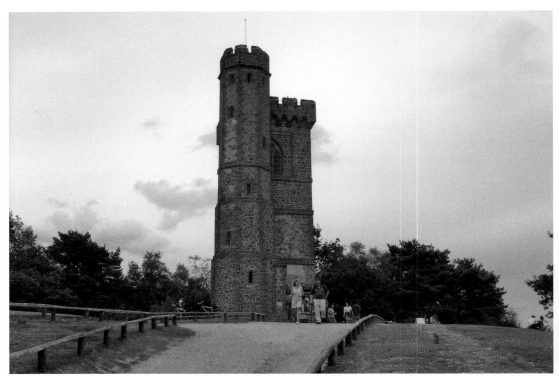

An epic battle raged here in Saxon times but is that same conflict still played out today?

discovered this ghastly deed and locked up the woman in a private room for the rest of her life. It has been said horrible screams have been heard emanating from the room where she was held captive. She has apparently been seen as well at the bottom of the stairs with severe cold spots around where her apparition appears.

Other accounts concerned the ghost of a child seen by the owner's daughters. Apparently she only appeared in the playroom which ultimately made the owners move out once their children gave continued comments about their '*little friend*!'

There is also thought to be a male phantom who stalks through *The Long Gallery*.

When visiting here, I found myself talking with one of the staff and when I approached the subject of the ghosts at Loseley House, she rapidly changed the subject – what did she have to hide I wondered?

LUMLEY CHAPEL

Cheam

Lumley Chapel is the oldest building in the London Borough of Sutton and has been standing for well over 900 years. In times gone by, this small and beautiful structure was

An ancestral seat to the More-Molyneux family for over 500 years, it is not surprising to find Loseley House a very haunted place indeed.

the nucleus of the ancient village of Cheam (mentioned in Domesday as '*Cheyham*'). Although not used for regular worship anymore, it still lies on consecrated ground and is under the protection of *The Churches Conservation Trust*. Now overshadowed by a nineteenth-century church dedicated to St Dunstan's (itself a replacement for an earlier Georgian structure); Lumley Chapel is all that remains of the original medieval structure.

Following the Dissolution of the Monasteries, Cheam was bought by Henry Fitzalan, Twelfth Earl of Arundel (*see Nonsuch Park entry*) who upon his death passed the Estate onto his son John, Lord Lumley. He is buried in the Chapel with his two wives Jane and Elizabeth along with their children who unfortunately died in infancy (commemorated on their mother Elizabeth's tomb chest). Lord Lumley's heirs retained the ownership of the Chapel well into the eighteenth century and are the ancestors of the well-known actress Joanna Lumley.

There have been at least two murders in or near the Chapel and on numerous occasions, screams have been heard coming from within the building whereby the police had been called only to find no one there. Many people have sensed a presence in the Chapel with one of my friends recording an EVP (Electronic Voice Phenomena) a few years ago that distinctly sounds like a man's gruff voice although there were three women present at the time.

Not so long ago at the adjoining St Dunstan's Church, a priest had died at the altar and he is still believed to haunt here. People who work in the Church have claimed to have seen his spirit, with one witness running out in tears. Graveyards are ominous places at the best of times and St Dunstan's Churchyard is no different. According to folklore, the first person buried in a Churchyard would be the Spirit Guardian of the area. It is believed that the early inhabitants of Cheam butchered the village simpleton by cutting his throat and allowing the blood to spill into the graveyard so to be the first Guardian. Underneath a concrete slab behind the Chapel apparently lies a plague pit with the bodies of fourteen children, victims of the Great Plague. One grave in the Churchyard marks the resting place of a young woman who was murdered along with her son many years ago. In an unusual example of graveyard plotting, her killer is buried next to her at ground level inbetween two graves, a final insult for this horrific crime of not being on consecrated ground. At the bottom of the Graveyard, a dark, oppressive force is said to project itself from an ancient tree and people have said its like walking through thick cobwebs although there is nothing there. There was also once a Well behind the old Caretaker's shed (once a stables) and many years ago an unfortunate

The oldest standing building in the London Borough of Sutton but what else does Lumley Chapel hold within its walls?

Screams have been heard from inside the locked Chapel in the dead of night.

victim, a girl called Lucinda Jarrett fell to her death (or according to many reports – *was pushed!*) and her spirit has been seen many times walking through the old building.

I had the opportunity to explore Lumley Chapel with the added privilege of it being the first paranormal investigation done here so I was eager to see what would present itself. Almost immediately, the team were startled to hear two prominent knocks against the wall although no one was outside. Whilst we acquainted ourselves with the surrounding area, the camera picked up a gentle whistling sound which we all heard clearly. We had only been in the Chapel a short time and things seemed to be happening already.

It was during a communication circle that the security light within the Chapel suddenly switched on automatically. This activity startled us as the lights are only activated by the main door opening and are on a limited time scale (the door had been shut for at least forty-five minutes) and no other sensors are in place in the building. This continued throughout our time here with the lights continually turning on and off and with many on command! I was later informed by the Site Manager that this simply could not happen and he was a little spooked himself when told of what had been happening! Faulty electronics or an unseen influence? I have still never figured out a normal explanation.

Lumley Chapel is a fascinating place to explore and I did wonder if former members of the Lumley Family were making their presence known that day?

MANOR PARK

Worcester Park

This interesting eyewitness account happened to a friend of mine Vicky in Manor Park in the early 1990s. She and a friend had been doing voluntary work at a local Youth Club and after they had finished their shift in the evening, headed to Manor Park and sat in the children's playground on the see-saw by a low fence.

As they relaxed chatting about everyday things, they both heard a loud noise that Vicky described as sounding like a '*HUH!*' Immediately after, both girls saw a pure white figure run across the field and jump over a fence before evaporating in front of them. The two of them could not believe what they just witnessed; saying at the same time, '*Did you see that?*' to which they both replied '*Yes!*'

Understandably, they walked out the park with a very quick pace (Vicky joked that she doesn't do running that well even after seeing a ghost!!!). The fact that two people witnessed the same phenomena at the same time also bears interesting conclusions.

This story has been recounted to me many times by Vicky and for her this was an incredible experience she will never forget.

MILL STUDIO THEATRE

Guildford

Situated next to the Yvonne Arnaud Theatre, The Mill Studio Theatre was opened in 1993 and houses many varied fringe plays and shows. As the name suggests, a mill has been on the site since possibly medieval times although the current structure was built in the late eighteenth century. During recent years there have been numerous reports of odd activity within the venue and a friend of mine called Peter told me of a weird occurrence that happened to him back in 2006.

Peter had worked as an LX technician at both venues and was locking up the theatre after a performance one night. He was doing the normal rounds of making sure equipment was safe and the lighting desk was powered down. As he was locking the main door, he distinctly heard footsteps from the floor above and naturally thought a member of the visiting company was still inside. Investigating this he found no one in the building although the footsteps were heard two more times as he tried to lock the door. On the final occasion, Peter ventured upstairs for one last look only to be greeted by a door violently slamming shut in his face!

Peter left the building very swiftly and although a very rational and logical person, he was very spooked by what happened that night. There is a possibility that at least five people lost their lives in the building in the early nineteenth century and could

Could people who lost their lives here in the nineteenth century still be haunting this building?

the violent acts that related to their deaths still be contributing to the oppressive atmosphere and audible phenomena that people have experienced here?

NEW HALL

Limpsfield
Although long since demolished, New Hall was built in the sixteenth century by London merchant William Gresham of Titsey. The Hall had a long reputation of being haunted or '*disturbed*' and this may have resulted in it being pulled down in the 1750s. Indeed the reputation around the area of New Hall persisted into the Victorian Era with reports of a phantom white lady being seen along Sandy Lane.

Other old accounts include people being pushed and shoved by unseen hands, dogs growling when passing here and a green mist moving silently along the Lane. Although not confirmed, there is a story of girl who was seduced by a Monk from the local Priory – she was so devastated at this cruel and callous attack that she committed suicide and it could be her ghost that still resides here.

NEWARK PRIORY

Ripley

Newark Priory was founded in the late twelfth century by Ruald de Clane and his wife Beatrice of Send as a house for Augustinian Canons. The Priory was dedicated to the Virgin Mary and Thomas à Becket and although now a ruin (much like Waverley Abbey), a lot of the original stonewall remains and is still an impressive structure. The River Wey which weaves past the Priory is off historical importance as well, being one of the first waterways to be navigable by barge in 1635. Its worth pointing out that Newark Priory stands on private land but you can still see the ruin from a footpath next to the river.

Not surprisingly, the figures of monks have been seen here over the years and they seem to be the main apparitions at the ruins of this grand Priory.

NONSUCH PARK

Cheam

The present area of Nonsuch Park was formerly part of the ancient village of Cuddington and it was here in 1538 that Henry VIII built his magnificent new palace which *'none such'* had existed before (hence the name). This grand structure swiftly replaced the old village, Manor House and Church (luckily the villagers were compensated) and was an unrivalled masterpiece of Tudor architecture with its polygonal towers and impressively decorated interior. Built around two courtyards, the Palace was about the size of a modern football pitch and was one of the most spectacular buildings in Renaissance Europe, even rivalling nearby Hampton Court.

Unfortunately, Henry died before its completion and it was sold to Henry Fitzalan, the Twelfth Earl of Arundel *(see Lumley Chapel entry)* but the palace only lasted a little over a hundred years. It all came to an end when King Charles II's mistress Barbara Villiers – Lady Castlemaine; was given the Palace by her Royal lover and was made Baroness Nonsuch. Villiers tragically had this grand building demolished in the 1680s to pay off mounting gambling debts and today there is very little evidence of this fine structure left above ground. An archaeological dig in the 1950s however uncovered some of its foundations and parts of the cellar. At the north end of the park stands Nonsuch Manor (now called Nonsuch Mansion), a much newer house built from 1731-43 by Joseph Thompson.

There are a numbered of reported sightings in and around the 300 acre park. At the eastern gate it is said that an apparition of a man concealed within a dark cloak stands watching the park as well as the sounds of partying in the small hours which have been heard coming from the former Nonsuch Palace!

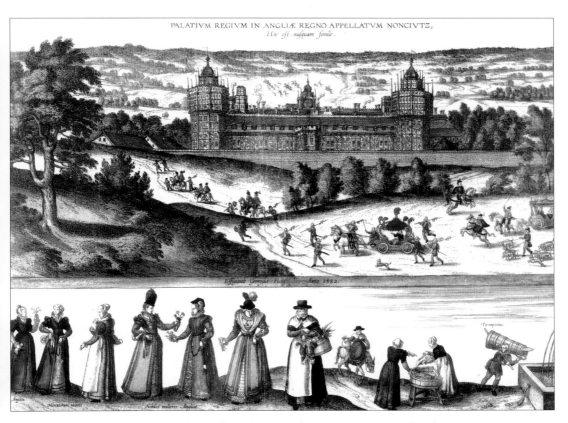

Sounds of revelry can still be heard from the ruin of Henry VIII's Nonsuch Palace.

NUTFIELD PRIORY

Nutfield
Built in 1872, Nutfield Priory has been vastly restored back to its original beauty and is now home to Health Spa although it could be said that the previous residents still have an attachment to this grand old building.

The Priory is said to be haunted by the apparition of a Nun as well as the following experience from a couple staying in the Milne Suite.

> *'What a beautiful room, but I woke in the night to see a lady in a bonnet and high neck dress watching me from by the curtains. We turned on the light and my boyfriend told me I was seeing things but then the (very hard to open anyway) bathroom door handle went and the door creaked open. The next day we were discussing it and the light next to my head in the bathroom flickered and went out – I've have never been so scared in my life!'*

OATLANDS PARK HOTEL

Weybridge

In 1649, a Manor House was on this site built for Robert Turbridge and his family to use as a country estate but unfortunately it burned down in 1794. A new structure was built in 1856, which became the Oatlands Park Hotel as we see it today.

There are a number of phantoms here who have not yet checked out of this fine hotel including a grey lady who walks through the restaurant. Up on the third floor on the Tudor Wing is room 1313 where there is apparently the spirit of a maid who jumped to her death from the bell tower after an argument with her lover. It is said you can feel the temperature change in this room but who knows how many drafts occur here?

THE OLD MITRE INN

Farnham

The Grade II listed Old Mitre Inn has the ghost of a smartly dressed soldier who seems to stand guard by the entrance to the Inn. The stairs are allegedly haunted by a couple who remain locked in love even after death. It's also been reported that the back of the Inn has the spirit of a nineteenth-century servant girl who could have been a maid in years gone by.

THE OLD RECTORY

Cheam

Another Grade II listed building is The Old Rectory. Dating from the early 1500s and stands near the historic Lumley Chapel and Whitehall (*see separate entries*) in the ancient village of Cheam although now engulfed by The London Borough of Sutton. This beautiful building stands in the vast area that was the estate of Nonsuch Manor; one of King Henry VIII's homes but sadly long since demolished. The Stables and Old Laundry are intact and The Orchards and Farmland (which once fed the residents of the Rectory) is now occupied by the New Rectory and flats in nearby Michelham Gardens. For many years The Rectors of Cheam were Bishops of Chichester and this post is still an important Church position. It is tempting to imagine the Rectory as being a kind of B&B for prominent visitors to the Court of Nonsuch, humming with gossip of the day. Queen Elizabeth I once said, '*I love well of Nonsuch air*' and few could disagree. The Virgin Queen also hunted in the adjoining park with her favourite, the Earl of Leicester. Centuries later, The Rectory was lucky enough to survive a bomb blast during the Second World War.

As you would expect from a property with such a rich and fascinating history, there are many stories and reports of paranormal activity. One of the original Rectors Bishop Lancelot Andrewes still walks here as does the apparition of a child who has been

This Grade II listed building has much reported paranormal activity derived from its 500 year history.

A Roman legion is reputed to have marched through the living room of the Old Rectory.

seen several times (most notably by the present Rectory owners). There is also a White Lady, a young maid, a malevolent male entity in the cellar and even a Roman Legion that marches through the living room wall towards the old village of Cuddington!

I was fortunate to spend a night here with the team at *Spiral Paranormal* that revealed some interesting experiences that may back up existing reports or uncover fresh ones. In the cellar for example, medium Alan Barnett picked up on a male presence who was killed in the eighteenth century in the nearby Red Lion Pub (*see separate entry*). Although this male had not passed in the cellar, his body was possibly brought here whilst it waited for burial. Interestingly, Alan had picked up on this same person a few weeks previously when he visited the nearby pub and sensed the murder at the Inn Well. In the main living room, Alan was also picking up on a nurse entering the room, which he explained was the same lady he had sensed in the nearby Whitehall some months earlier. Plenty of light anomalies were captured on camera but I am not going to comment on whether they are unexplained or not but just what was witnessed!

Much activity occurred on our night here with light anomalies, unusual energy readings, the apparent sound of a servant's bells and medium Alan Barnett becoming very emotional in the upper bedrooms as he picked up on a woman who died in childbirth. With The Old Rectory's strong connection to the village of Cheam, this historic property still retains a lot of its former character and possibly, a lot of its former '*characters*'!

THE PERCY ARMS

Chilworth

The village of Chilworth, along the beautiful Tillingbourne Valley was once home to gunpowder production and was an industry that lasted in the area for 300 years until it finally closed down in 1922. As would be expected, this was an extremely dangerous and risky profession and although many safety precautions were in place (even by today's standards), accidents frequently occurred and many were fatal.

One of the last major incidents was in 1901 when a huge explosion killed six workers and body parts from the unfortunate victims were found spread throughout the area. These accidents brought many coroners and investigators to Chilworth and they would set up office nearby in The Percy Arms Pub to view evidence and scan the remains of victims to conclude their verdicts.

Maybe as a result of this, The Percy Arms has had a long history of disturbed or poltergeist activity. For many years objects were constantly moved and doors would slam by themselves. Over the years the locals have named this mischievous spectre '*George*' after George Smithers, who was one of the victims of the explosion.

Another report concerns a man on a bike returning home from work in the early hours of the morning along the road by The Percy Arms. He became aware of another cyclist just in front of him but riding with no lights on his cycle. The man caught up with the second cyclist to be startled to find the figure had no face but just a blurred image!

Disturbed activity has been reported at this Chilworth Inn near the old site of gunpowder production.

PILGRIMS WAY

Dorking
The ancient track way known as the Pilgrim's Way, stretches from Winchester to Canterbury and passes through parts of Surrey but most prominently at Box Hill (*see separate entry*). This pathway may have been used by travellers for centuries and gets its name from the pilgrims who may have used it to visit the shrine of Thomas à Becket at Canterbury Cathedral – although historians now agree that this was very unlikely with little or no evidence to support this. It should be noted that pilgrims for Becket's shrine would have come from all over Europe and not just from England. There is speculation that the route was used as far back as the pre-Roman occupation (around 500 BC) as the pathway travels a pre-existing track way.

Assorted apparitions have been seen along this ancient route including weary travellers stumbling over the stepping-stones that cross the River Mole at the foot of Box Hill and a phantom rider galloping along the path at night.

Many apparitions have been seen along this ancient trackway along the North Downs.

PIPPBROOK HOUSE

Dorking

Now occupied by the offices of Mole Valley District Council, this site was originally home to a medieval Manor House built in 1378. Although the old Manor is long since gone, former occupants may still wander around the modern offices. There is a lady seen who regularly descends the stairway and a man has been reported staring out of an upstairs window.

POLESDEN LACEY

Bookham

Originally known as '*Bocheham*' in Saxon times, the town of Bookham was first recorded in the Domesday Book and this charming place was where the author Jane Austin spent some time in the 1700s writing her famous novels.

Just outside the town and nestled in vast parkland is the magnificent Regency house of Polesdon Lacey. It was designed by Thomas Cubitt in the 1820s but

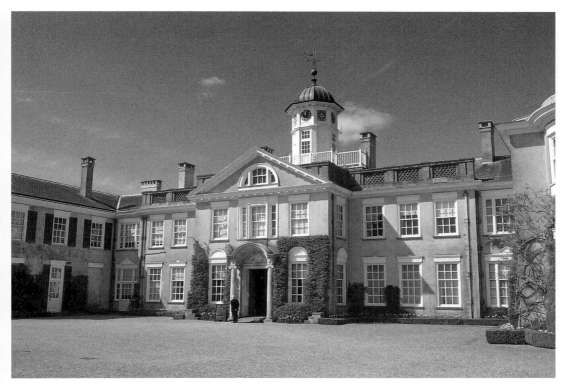

Could it be the grounds around Polesden Lacey where activity has been witnessed rather than the house?

remodelled in 1906 although there has been a house here in one form or another since medieval times. Indeed the name '*Polesden*' is of Saxon origin and one of the earliest owners was one Herbert de Polesden. Of course one of the most flamboyant residents of Polesden Lacey was Mrs Granville, an aristocratic hostess who did much entertaining for many distinguished guests including the Duke of Kent (later George VI) for his honeymoon.

The 30-acre Edwardian Garden is very impressive with a walled rose garden, terraces and 10 acres of lawn which not surprisingly can be very crowded in the warmer months especially during the open air Festival. Since 1942 the Estate has been managed by the National Trust.

And there are of course its ghosts although most of them seem to be in the grounds as opposed to the house itself. *Nun's Walk* for example is rumoured to be haunted by a mysterious vortex of energy and near the bridge has been seen a ghostly, hooded figure in a brown cloak. Although when I visited here one of the volunteers who had been working there a number of years assured me that '*the house is definitely not haunted!*' I do hope he is wrong!

PORTSMOUTH ROAD

Cobham

There are many stories across the country telling of phantom hitchhikers, flagging down unsuspecting motorists looking for a lift in the darkness of night and Surrey is no exception.

This following incident took place on a very wet night in 1947 along the old Portsmouth Road in Cobham. It was late in the evening around 11.00pm and a man was driving past The Tartar Pub (now long since demolished) when he noticed a young girl trying to wave him down by the side of the road in the heavy rain. Nowadays that might not seem unusual with pubs and clubs staying open till the early hours but it was a different story in post-war Britain.

He decided to pull over and the pale, rain soaked girl silently climbed into the back of the vehicle. He drove off although there was no communication from the girl; she sat silently with a fixed stare on the road ahead as the car entered the High Street with the man still unsure of his passenger's destination. It was approaching midnight when he stopped the car at Church Street whereupon the girl left the car without a word of thanks and ran off in the rain towards a house on the other side of the churchyard.

A few days later and still perplexed by what happened, the driver started talking about the incident to others in the area and he was shocked to hear that this could be the ghost of a girl who had died ten years previously! It is believed she had seen had been out drinking at The Tartar Pub with friends but when she was back home later that night, she had fell asleep and a fire broke out which tragically suffocated her during the night. Whether this is the same girl who the driver witnessed is hard to verify but it's certainly a tale to take note off next time you pick up a passenger along the old Portsmouth Road!

PRIVATE HOUSE 1

Chessington

We had been contacted by a lady who was interested in seeing what if we could help with alleged spirits in her home who had been making their presence known quite freely. This was a perfect opportunity for us to do a first investigation with medium Alan Barnett and he contacted me to set things up. On this occasion, we hadn't a chance to do a recce and literally turned up at the house not knowing what to expect.

Whilst we acquainted ourselves with the property, Alan decided to do a lone vigil in the master bedroom with a video camera to tune in to any alleged spirit presence and prepare him for the evening's investigation. Although he had responses to his questions, nothing was caught on camera.

With the team assembled, we started the investigation proper in the main living room. With an old fireplace in the corner, Alan tried psychometry to tap into potential spirit energy – this involves a psychic simply touching an object and using it to receive information. Almost immediately, he picked up on an older male spirit presence, which

he described as being unkempt and untidy as though he had let himself go. Alan also felt that he was a bit of a crotchety fellow and had suffered personal loss in his physical life as he shuffles around the house. We attempted various call outs but had no response contrary to Alan's earlier lone vigil.

Moving to the stairway, Alan quite strongly sensed an accident involving a person falling down the stairs, which he believes he identified as the man's wife. Although he sensed she didn't die here (rather passing away at a hospital), he did sense a feeling of loneliness from the elderly man and that he was strongly connected to the house, falling into loneliness at the loss of his wife. Rather interestingly the lady visits the house also to find her husband but for some reason they cannot connect with each other. We felt certain cold spots around the top of the stairs but after our vigil here, we realised this was due to an open window in a nearby bedroom – always eliminate every rational possibility before reaching an explanation of something being paranormal.

The team headed back upstairs to the main bedroom where Alan had done his lone vigil earlier. Various call outs were conducted to bring any potential spirit closer. At this point Alan picked up a name '*George Williams*' and as well as his wife, he sensed that a son had also died at some time during the Second World War (possibly in action but he wasn't sure). As he called out, he felt something touch his face, which is something he said he is used to – this could of course be nothing more than a natural twitch or an insect. Alan asked for any energy present to touch another member of the team but nothing occurred although he sensed someone sitting next to Patricia on the bed.

In the second bedroom, Alan, the owner and myself attempted further communication. A few faint knocks were heard to prompted questions but it's difficult to work out what they were – if indeed they were coming from anything disincarnate. I pushed this a little further by asking whatever spirit was with us to make the dog bark – as if on cue the dog started barking in the adjoining bedroom in direct response of my asking for this to happen. The owner informed us that this was very unusual (this occurred a couple of times during the night) as the dog was usually quiet animal whilst in the house. As we continued, team member Patricia walked round the first floor landing taking various pictures while Duncan attempted to record some EVP (Electronic Voice Phenomena) downstairs through a laptop. Duncan has worked with sound for many years in both music production and as an engineer and very knowledgeable about frequencies and audio ranges. On this occasion he set up a Seinheiser microphone attached to the computer and whacked up the audio gain.

After a short time, we joined Duncan in the spare room (and our crew room). Remarkably he had recorded a very interesting EVP whilst we were upstairs although strictly speaking it was movement rather than voices. Playing back on headphones, the recording sounded very clearly and audibly like a door opening and a shuffling of feet. With everyone accounted for (and we were all sitting down at the time) and no doors shut at this point, we were bewildered at to what this could be? With Duncan being very knowledgeable about sound, he assured us that he was sitting quietly during the one minute of recording and heard nothing at the time. Even to this day I have never quite understood what this could be.

Is a former resident still keeping an eye on his former home?

Excited by this we attempted a séance. A candle was placed on the floor with Alan, Patricia, the owner and I sitting around with Duncan monitored sound once again. A few flickers of the candle occurred in response to questions but this was just coincidence.

As the investigation drew to a close, we discussed the evening's events – were former residents making their presence known more audibly than visually? We still can't satisfactorily explain the recording and no sound was picked up on camera upstairs at the time of the recording.

PRIVATE HOUSE 2

Chessington

Staying in Chessington, we had another situation of peculiar activity within a quiet suburban home back in 2008. Like the other cases in the book dealing with human emotions, the concern first is the wellbeing of the clients with any alleged paranormal reasons being secondary. Although the home forms part of a modern road of terraced houses, the land backs onto ancient woodland which was once the site of a medieval settlement.

We met with the owner of the house and once again, she told us that it seemed to be centred round the children of the home. This included various noises coming from

upstairs, objects moving by themselves, banging on walls in the middle of the night and the daughter seeing a shadow at the foot of her bed with the bed covers being pulled off whilst she slept. Even the young son had taken to praying in his room to '*keep away the nasty people*' as he has said – this is from a child who does not have a religious family and no one knows where he gets the praying from as he didn't go to pre-school at the time or seen this on TV!

Joining me on this investigation were colleagues from the paranormal radio show '*Tuning In*' which we were part of in 2008, including medium Paul Cissell who we hoped to uncover what was happening here. With no prior knowledge of the area or its history, Paul had already identified the ancient settlements which originally stood here and we wondered what else would be revealed as he began his walk round of the house. According to his assessment, Paul realised it was a busy household with plenty of energy being created by not only the children but the adults as well. It was this Paul said, that is causing the disturbances within the house. Whether any active spirit here was contributing to the phenomena could not be established but there was a presence picked up on in the bedrooms and the attic. At the end of the evening, Paul took the owner away privately to discuss what he felt was going on and to reassure her that nothing negative was in the house to disturb their lives.

With what seemed to be both a spiritual and psychological paradox created by the occupant's own energy and of the surrounding area, the family seemed much happier with the atmosphere in their home and regardless of the reported phenomena, the important thing is her satisfaction that whatever energy may have been residing here would not be affecting home any longer.

PRIVATE HOUSE 3

Richmond

This intriguing story was told to me by my friend Giuliano, an actor and architect who is a very sceptical and logically minded fellow indeed. I shall let him describe the following experience:

I have come to think that any proof of the existence ghosts lies not in empirical scientific physical evidence but in having knowledge of the characters recounting their encounters with ghosts. And I say this as an architect with some scientific training. If you ask me straight off on a cold blustery morning, bundled up to the gills with coat and hat when my own personal disposition at that precise time is one of profound physical discomfort, if I believe in ghosts, my riposte will be sharp and abrupt and defiant negative. And even if you asked me the same question sitting by a fire with in a warm cosy pub by the fireside a glass of port in my hand, I would still defend the scientific point of view that I as far my reading on the subject goes there has never been any concrete proof of ghosts. Not one. And yet, these stories I offer up are my own, what shall I say, encounters is much too strong a word, minor examples of evidence that might level some doubt over the very rigid scientific perspective on

such matters. It is very easy to completely dismiss any point of view that accepts the presence of ghosts. But when one is alone, in a darkened space, one has to face one's very own judgment on this issue, and if you hear a bump in the night, it is alone that you have to act, and as you will read in one of these stories, it was not my mind but my legs that did the running.

My sister and I used to love to fight. Wrestle, compete at any board game, climb the walls and furniture in our apartment. She was veritable tomboy, desperate to keep up with the gang of boys that roamed our communal gardens in Richmond, populated by the kids of quite effete gentry, a set which we were most certainly not part of and so we were not all that tough really. But sis was game for any outdoor wild game and when indoors a real rough and tumble pillow fight was the order of the day, particularly when lights were out and is was Nanny's night off.

Well this particular night was a very quiet one. I could hear the TV in the room next door, a cowboy film my parents were watching. It was one I had seen a dozen times, with the deep and rumbling tones of John Wayne trying to calm the hoards in the pre-punch up shoot out scene.

Suddenly I felt something on my shoulder, a very familiar but out of context squeeze. Giving very little time to reflect on this, as my combat brain kicked in, I flew out of bed armed with my pre-prepared pillow ready for mid corridor skirmish. But there was no one there. I walked on down to my sister's door, knowing full well that she could never have made to her room in time and saw her door was closed tight, which could not have been achieved in the time and without pulling the door hard to make the latch click into place. Puzzled I opened her door and entered. She was in bed reading, and I could tell immediately that this was no act.

I went back to my room and listened to the night sounds; the constant distant sound of cars streaming outside and the TV next door. I heard some bells ringing, very similar to the ones that would usually be in a cowboy film situated in Mexico, a ring from a bell that was made from very thin copper. But listening more closely I could tell the TV scene had no need of bells. I was confused. Once again I felt my shoulder being squeezed, and shot out of bed. The corridor was deserted.

I thought about this a lot, trying to work out what was going on. When it happened again I went into my parents, and told them what was happening, and mom scooped me up, tucked up in bed and stayed with me until I feel asleep.

Now as a small boy I used to go down to the film studios with my parents to watch Mario Zampi on the set directing Peter Sellers in one of his first film roles. I used to stand between Mario's legs as he sat in his director's chair, resting his huge, eternally cigarette filled ham hands on my shoulders as his barked out his directions in his very broken English.

Next morning, I went into mum who was preparing breakfast, and told her not to worry as I had figured out who it was that had been grabbing my shoulder in the night. I said 'it was Nonno', (Grandpapa in Italian). Only her head turned, the rest of her body was paralyzed from the shock.

Mario had died in the night!

PURLEY ARMS

Purley
In 1992 reports of disturbed activity at this pub resulted in a couple of mediums and an astrologer being brought in to *'rescue'* the troubled spirit (why an astrologer would be called in to do this baffles me however!).

The spirit was allegedly identified as gentlemen called *'George'* who had been killed in 1830 when his back was broken by a beer barrel falling down a ramp in the cellar. With a reporter from the *Croydon Advertiser* in attendance, the alleged *'clearing'* seemed to do the trick and the pub's atmosphere returned to normal.

PUTTENDEN MANOR

Lingfield
Built in the late fifteenth century, this timber-framed Plantagenet Manor House has had little alteration done over the years and was probably once moated. A smell of perfume emanates from the master bedroom as has been linked to a female spirit who haunts this area along heavy footsteps and strong tobacco from downstairs.

PYRFORD STONE

Pyrford
This is a tale more stemmed in local folklore than anything else but still a nice example of local legend. By Pyrford Court stands an ancient stone that has origins far back in time with an attached plaque reading:

> *'This boundary stone dates from before the Norman Conquest and is possibly a prehistoric standing stone. Situated on this corner since time immemorial, it was moved to its present position during road widening. This plaque was donated by local residents in 1976.'*

Much folklore has built up around the stone with old stories of it moving about at midnight when the clock at St Nicholas Church strikes midnight (although the Church has no clock!).

RECREATIONAL HALL

Sutton
Some friends had asked to know what it was like to experience a paranormal investigation and eager to oblige, I arranged a private vigil at an undisclosed location in Sutton for Hallowe'en 2007.

What was formerly on this site may contribute to its haunted reputation?

The property in question is now used as a Recreational Hall but the building itself forms part of a much larger area. The original buildings on this site were first used as part of a South Metropolitan District School, which was an Industrial School for children of workhouse inmates in South London. The site later became a Psychiatric Hospital, before being demolished in the 1980s and is now used as part of a modern hospital. With many images of light anomalies being photographed in this building on an almost regular occurrence, we wondered if anyone else would join us on this Hallowe'en evening.

This was going to be a short vigil due to time restrictions but the guests were all eager to begin. The team present has used this location over the last couple of years and many people including staff have felt a presence that was unexplainable. We positioned a table by the back wall where the majority of light anomalies had been captured. In the corner, three coins were set up as trigger objects along with a locked-off camera and my friend Ben was on hand to take photographs. Various call outs were made but all seemed quiet although Alexis seemed to sense a man in his pyjamas (an ex-patient maybe?) who was curious at what we were doing. Alexis does not claim to be psychic by any means but has been correct on information in the past. Various members of the group felt cold rushes but as this was their first investigation, it's hard to determine if it's all in their mind and too much influence from media output.

Ben captured many light anomalies throughout the evening that were mostly concentrated around the table and team but these can easily be explained away as air particles and dust from the floor. Using an EMF (Electro Magnetic Field) reader, I checked the surrounding wall before handing the device over to Alexis where a higher reading was continually emitting around Kathleen. This could have been cables underneath the flooring but this unfortunately couldn't be checked. Although it was a short investigation it was still interesting to bring in new people to experience a vigil and some of the processes of an investigation. The Hall and site have much history dating back to the nineteenth century and according to current reports, it continues to offer odd goings on among staff and visitors.

THE RECTORY

Caterham On The Hill
Situated between the junction of Caterham on the Hill High Street and Whyteleafe Road, the Old Rectory sits nestled behind large trees and looks pretty much the same now as it always has except perhaps for the company name board outside. The original parts of the Rectory date back to sixteenth century and was once in the possession of Waltham Abbey.

The first reports of strange goings on started at the beginning of this century when Reverend Alick St John Heard and his wife moved into the property shortly after his father Prebendary Heard retired to the West Country. Footsteps seem to be the main focus of the reported hauntings and are usually heard on the First floor corridor when the home owners are alone in the house and doors are often found open when they have been previously closed. This happened so often for the Rector that he conducted an experiment. Before going for a walk he locked all the doors and he left with his wife keeping hold of all the door keys – on their return they found every door was wide open!

Throughout the years the reported occurrences continued with such phenomena as rattling door knobs, slamming doors, apparitions of an elderly gentleman, doors opening on their own, windows being found open when returning to the property, a depressing atmosphere, footsteps, apparitions of a Victorian child and a hooded figure (reported to be a monk), moving objects and music being heard. Swirling mists have also been seen outside near the ancient apple tree and there is possibly still an old oak door embedded with nails in the house. There is a nail for each person who died when the plague hit Caterham.

Mediums who have visited the Rectory claim that in the past the building was used as a hostelry and a resting place for monks on long journeys. One medium declared that the front of the house was possessed by good spirits and those at the back by evil and also claimed that a skeleton had been found in a shallow grave by the back door.

Today, the property has been converted into offices but there are still reports of strange things going on to this day.

REDHILL AERODROME

Redhill
Just like RAF Biggin Hill in Kent and RAF Kenley, Redhill Aerodrome has its share of mysterious occurrences with the main hangar (which used to house a museum) seemingly to be the focus of many unexplained events. Everything from sounds of knocking, heavy presences and even kettles which switch themselves on have been reported here!

On one occasion in the main hangar, a volunteer was working late one night in a back room with the main door to the hangar firmly locked. Suddenly the volunteer was disturbed to hear the main door opening and closing and went to investigate thinking it was another member of staff entering the hangar. He found no one there and as he approached the hangar door, he distinctly heard the sound of movement in a nearby corridor and the crashing of an inside door in a very forced and deliberate way although the main door was still locked. This occurrence has happened numerous times, for example another volunteer had heard footsteps in an outside corridor whilst also working late one evening and once again, the main door was closed!

Of course with an old and rusty hangar, noises along with the general ambience of the building will of course contribute to odd audible sounds but no satisfactory explanation has yet been given to the experience the volunteers had.

Aircraft hangars and Airfields are fascinating places to explore (having already done a paranormal investigation at *RAF North East Aircraft Museum* in Sunderland) and one wonders about the many brave pilots who were not fortunate to return from their missions but still have a link to their former base – maybe still waiting for further orders.

REIGATE PRIORY

Reigate
Founded in 1235 by William de Warenne who was the 6th Earl of Surrey, this Grade I listed Manor House is surrounded by 65 acres of parkland and is a now a school and museum. There are reports of a ghostly monk who supposedly haunts the Priory halls and there is speculation that stories of this phantom stretch back many years.

RICHMOND PALACE

Richmond
With only the Gatehouse remaining, Richmond Palace had a long association with English Kings and Queens and it's a shame that it was in ruins by the seventeenth century. It was originally built by Edward III with Henry V rebuilding it after it was utterly demolished. Henry VII died here in 1509 and the notorious Henry VIII gave Anne of Cleves the Palace as part of their divorce settlement.

Although Queen Elizabeth I came to Richmond many times during her reign, notably to hunt stags at '*Newe Parke of Richmonde*', it was at the Palace that she came to stay in the last few months of her life. Knowing that the end was near, she sat for many hours in silence, refusing to lie down for fear of never rising. Unfortunately Elizabeth – one of England's greatest Monarchs died here on 24 March 1603 and it is said that Elizabeth's spirit still roams the Gatehouse where she spent those last moments of her life.

RICHMOND THEATRE

Richmond
This beautiful Victorian Theatre opened its doors in 1899 and has been providing entertainment for well over a hundred years. Originally called The Richmond Theatre and Opera House, the venue is now a receiving house for national tours and pre-West End productions.

Just like Richmond's sister venue at Wimbledon (*see separate entry*) stories of ghosts and phantoms still linger on in this grand building. There are supposedly three phantoms that roam the corridors of this stunning Theatre. One is apparently a former director who accidentally fell to his death in 1939 from the balcony with another being an elderly gentleman who walks into the ladies' toilets. During a performance of '*All You Need is Love*' a woman appeared in the gods behind the main stage.

RIVER WANDLE

Carshalton
With its source near Carshalton Ponds, this ancient waterway runs 9 miles up to The London Borough of Wandsworth where it flows into the River Thames. There is evidence that the river was used in Roman times though the name '*Wandle*' derives from the Saxon '*Wendleswurth*' meaning '*Wendell's Settlement*' which eventually became known as Wandsworth. The river today is a haven for wildlife as it weaves through the suburbia and areas of Greater London.

As a young boy, I had heard stories of a lone phantom boatman who would quietly row past woodland in Carshalton near Butter Hill, which is now a Wildlife Sanctuary. If I ever passed this way in my Dad's car, I would always peek through slightly covered eyes at the possibility of spotted this spooky boatman – but just like the phantom Nun at The Water Tower in Carshalton (*see separate entry*) – I never did!

ROYAL OAK PUB

Bookham
Along Bookham's quaint, narrow High Street stands the Royal Oak Pub that dates back to 1450 and still retains many of its original features. Previous investigations

This Bookham pub has a long history and long association with hauntings.

from paranormal groups have apparently revealed a young boy haunting the upper floors and bizarrely, a woman in a cleaning cupboard in the main bar! An investigator even felt the presence of hand firmly touching their shoulder.

I visited here with medium Alan Barnett and he did pick up on a woman in the main bar area who seemed quite content in her surroundings – she *didn't* seem to be emanating from the cleaning cupboard however!

THE RUNNING HORSE

Leatherhead

Situated in Bridge Street overlooking the River Mole, The Running Horse was built in the fifteenth century although there has been an inn on the site since 1403 and was originally named Rummings House after the infamous Eleanor Rummy. King Henry VIII's poet John Skelton wrote a poem about her which can be seen on the wall of the pub today and a painting of Eleanor Rummy used to hang in the pub during the 1970s. It is not certain whether this has been moved or whether it remains in the building.

Is Eleanor Rummey still haunting this Leatherhead pub?

So who was Eleanor Rummy? Eleanor was the landlady during the fifteenth century and she was accused of witchcraft. Legend has it that she was nailed into a barrel and rolled into the river via a tunnel leading from the pub's cellar directly to the river; which was the route taken by her murderers so as not to be caught in the act. The witchcraft allegation was never formally made and no trial took place prior to the conviction and punishment of the (very probably) innocent woman. An alternative version of events states that she was discovered to be watering down the ale. This angered the locals who accused her of witchcraft and spread rumours about the innocent woman before carrying out the most severe of punishments. She was apparently not the most beautiful of women to say the least and this may have added to her taunts!

The tunnel is no longer visible and there is no evidence that it ever existed at all although as with all ancient buildings, numerous renovations have been carried out over the many years of its existence and so it is possible that it has been blocked, sealed and hidden. Rumours of the pub being used as a regular meeting venue for smugglers during the seventeenth century could be considered as further proof of the tunnel's existence at least until around this time. Again, there is no documented evidence.

Robert and Susan Gibb (parents of Mandy, one of the team at *Spiral Paranormal*) managed the pub during the 1970s and during this time, they reported a number of strange incidents including banging sounds coming from upstairs when there was nobody up there, constant feelings of being watched in the cellar, cold spots and the sound of footsteps with no visible owner. They had a dog at the time that was happy to roam around the building but refused completely to enter the upstairs room at the front of the building overlooking Bridge Street. In attempts to coax the dog into the room or to get to the bottom of the reason why she would not enter there, Robert put her food in the room over three days. Despite being ravenous; the dog still refused to enter the room, getting as far as the threshold and then stopping with her teeth bared and her heckles raised. As soon as her food was moved out of the room into the hallway she wolfed it down without a second thought!

On another occasion, landlady Susan had finished cleaning the cellar which was a task she completed at the end of each day despite feeling most uncomfortable being alone there. She often felt the sensation of being watched and occasionally had a sense of panic – as if she wanted to run from the room. There was no obvious explanation for this feeling and is not a sensation she has experienced in any other building. On this particular day she noticed something shiny right in the middle of the floor she had just swept and on closer inspection she found it to be an old silver bracelet. It was the kind that had a compartment for holding a lady's dance card and dated from the nineteenth century according to a local jeweller to whom she took it for inspection. How this appeared in the centre of the cellar floor that had just been cleaned (and cleaned daily by Susan for the past three years) is a mystery to say the least. Only Susan and Robert were in the building at the time and the pub was closed so who was the original owner? Where did it come from and why? These are questions that have never been answered.

Staff working in the pub over recent years and even today also report similar experiences – the cold spots, the indisputable feeling of being watched, shadows moving across the upstairs hallway, doors opening and closing seemingly of their own accord. Could be the old building, warped wood, draughts etc or maybe it is Eleanor Rummy or one of her murderers?

There are also rumours of an overnight stay by Queen Elizabeth I when the River Mole flooded and became impassable although this cannot be verified. The Running Horse is a beautiful, old and atmospheric building with both a very interesting history and some fascinating tales to tell.

SANDROCK PUB

Shirley

On Upper Shirley Road stands The Sandrock Pub, which was built in 1867 and has had a long association with paranormal disturbances.

The prominent spectre here appears to be that of a preacher and is maybe the spirit of a religious man who used to deliver sermons from a rock nearby in the nineteenth

century (hence the name). A former landlady who was sensitive to spirit claimed that she awoke one night to see this preacher at the bottom of her bed!

SELSDON PARK HOTEL

Croydon
Although it has had many alterations and facelifts over the years, there has been a building on this site for well over a thousand years (possibly dating back to AD 861) with the current structure being Victorian. Now a Golf and Conference Centre, it boasts some incredible views over the North Downs countryside.

One of the corridors was built in the 1920s and walking along here carrying a candle is an apparition of a young maidservant who apparently committed suicide back in the 1930s. One guest staying at the hotel reported catching the reflection of another ghost in a mirror while in the bath. There have also been instances in *The Phoenix Room* and the *Cambridge Wing*. When I attended a wedding here I thought better of mentioning to the newly-weds about the reported phenomena as they were staying in one of the haunted bedrooms!

SEVEN HILLS ROAD

Cobham
Back in 1966, a cyclist was riding down this road and reported going straight through an elderly lady who stepped right out in from of him.

SHAG BROOK

Buckland
This is a tale most definitely steeped in folklore but still a fascinating story of the superstitious beliefs of long ago. A mile outside Reigate is a small stream called Shag Brook where once lived a ferocious water monster called The Buckland Shag. It terrorised the local community and would eat unsuspecting travellers. There are stories from Old Surrey of brave soldiers who would attempt to face this fearsome creature only to never been seen again or return to the local village in a state of utter shock and horror!

The Buckland Shag hasn't been seen for many years however so you should be safe in seeking out the Brook yourself to see if you can find any traces of that terrifying beast. Of course, it's just the stuff of legend – or *is it?*

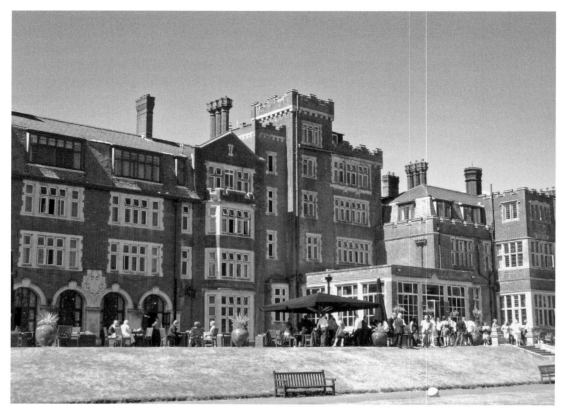

There are numerous reports of activity within the many rooms of this Selsdon hotel.

SILENT POOL

Shere

Just off the A25 is a small lake commonly known as the Silent Pool (its real name is *Shireborne Pond*) and is set in tranquil woodland near the villages of Albury and Shere. Originating from springs from the North Downs, a natural process leaves the water completely clear with a stunning blue-green colour and is a popular destination for walkers during the summer months.

Some historians and folklorists believe the pool may have been used for sacred rituals in ancient times although there is little evidence to support this although springs and bodies of water are often used as places of spiritual and religious worship. The pond was originally thought to be bottomless (a familiar legend with pools throughout England) and the waters were supposed to have healing properties. Indeed, the old local Fair at Albury which was held on Palm Sunday would have bottles of the water made available for the villagers.

There is a tale of a phantom girl who haunts the pond from long ago. The story goes that a Woodcutter lived in the forest by the lake with his son and daughter. The

daughter spent many hours bathing in the lake (given this country's climate that must have been cold!) and on one particular day she was disturbed by the approaching sound of a rider on horseback. To protect her modesty, she waded back out into the pool to cover herself as the man dismounted and beckoned her to the shoreline. This made the man angry as she moved further away from him and into the middle of the lake. Panicking she started to scream that made the rider flee into the forest as her brother arrived to see his sister struggling in the water. He tried to rescue her but tragically they both drowned. It is said that the dastardly horseman was that of Prince John, the Regent of Britain – a man who is well known in history for his evil ways.

The phantom girl seen here is said to be that of the drowned Woodcutters daughter. There are tales of her screaming in panic echoing around the pool and a figure is seen in the middle of the lake before disappearing as the water returns to its eerie calmness.

It's an interesting tale but unfortunately it's complete nonsense, nothing more than a fabricated story made up in the nineteenth century by the local author and poet Martin Tupper. Tupper had a reputation as one of the worst poets of his day with him described as '*a poet who did not know what poetry was, who wrote for other people*

Is it folklore than fact that presides over this ancient pond?

who did not know what poetry was'. Tupper himself was delusional regarding his own work and brilliance and was convinced he would be made Poet Laureate one day! It's a shame that some people still believe it to be true regarding this myth (that still persists to this day) although there maybe an old report of a ghostly girl seen here but the rest is pure fiction!

SLYFIELD HOUSE

Bookham

The Manor at Slyfield House in Bookham originally dates from the fourteenth century but the house was rebuilt during the Jacobean period by George Shiers. It was under his ownership that prompted the rebuilding and the house seen today is pretty much as it was 400 years ago. Members of the Slyfield family lie in the fifteenth-century Slyfield Chapel of St Nicolas Church. There was once a Great Hall attached to the house but this is gone and now occupies part of the Farmhouse which would have been living quarters for servants of the house.

As can be expected from a property of this great age, Slyfield has its fair share of ghosts and spirits. Most bizarrely, an apparition of a blue donkey (yes *blue*!) has been seen supposedly leaping over the dog gate at the bottom of the stairs and vanishing at the top. There is even a painting in the hallway depicting this phantom animal surrounded by a blue haze!

Upstairs is a haunted bedroom where many strange occurrences have been reported. Guests staying here have heard the sound of horses in the courtyard below only to be told that this would be impossible as the old courtyard is long gone. There is also an apparition of a cavalier seen here who may have been hiding from searching roundheads during the Civil War. Guests have said that the room has an oppressive atmosphere and there is a constant feeling of anxiety and nausea.

Then there is the ghost of Sir John Fenwick who in the 1690s had taken refuge at Slyfield. Fenwick had been involved in a plot against King William III and was being pursued by the King's men. He foolishly thought Slyfield would be a safe haven but he was eventually found here and taken to London where he was executed. Fenwick's spirit is said to wander the corridors and rooms of Slyfield and maybe he's still trying to hide from his pursuers centuries later. The gardens at Slyfield also play host to a Grey Lady who walks about wearing a sad expression over a weary face.

ST ANDREWS CHURCH

Cobham

St Andrews in Cobham dates back to the twlfth century, though it has been through extensive renovation during its 800-year history. The church is supposed to be haunted by a strange apparition – that of a blue donkey just like at Slyfield House (*see separate entry*).

Singing and chanting has been heard from this Farnham Church.

ST ANDREWS CHURCH

Farnham

Built in the twelfth century, the Grade I listed St Andrew's Church is one of the most important buildings in the town and is the nucleus of Farnham.

This fine church has its fair share of ghostly phenomena. The notable reported sightings are that of an old lady who walks around the churchyard but vanishes when entering the building. Inside the church, the sound of Latin chanting and signing has been heard very much like it would have been in pre-Reformation days.

ST CATHERINE'S CHAPEL AND ST MARTHA'S CHURCH

Guildford

Set on top of St Catherine's Hill just outside Guildford, the ancient ruin of St Catherine's Chapel was built in the fourteenth century on what was most probably an earlier sacred site. Richard de Wauncey commissioned the Chapel in 1301 who was then Rector of the Parish Church of St Nicolas. It was built for the purpose of having a place of worship closer for the local people who had to travel longer distances.

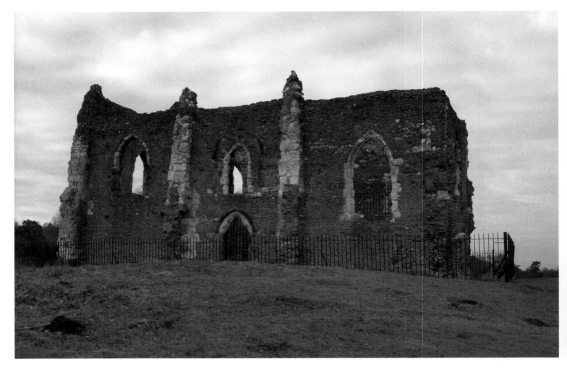

Legend has it that two giants built this Chapel and the nearby St Martha's Church but what still resides here?

A fair took place each year on the 2 October and attracting a gathering from all over the area but was eventually stopped as the revels got out of hand with the event continuing on a smaller scale until the end of the nineteenth century. Both sites are linked by The Pilgrim's Way (*see separate entry*).

Just over a mile away the nearby St Martha's Church was built upon an old pagan site and local legend tells of two giant sisters called Catherine and Martha who when building their respective chapels had only one hammer between them and continually threw it across the hilltops when one of them needed it.

The nineteenth-century Victorian yachtsman J. B. Dashwood also commented on the legend of the two sisters in 1868:

'The views from the tops of St. Catharine's and St. Martha's hills, on which are situated chapels of interest, are lovely, and in fact there are endless points in and around Guildford from whence fine views are obtained. The old legend records that two sisters, Catharine and Martha, built with their own hands the two chapels which still bear their names. These ladies were of the giant race, and the only working tool they used was an enormous hammer, which they tossed from one hill to the other as it was wanted.'

Visiting St Catherine's Chapel with medium Alan Barnett, I was expecting the obvious information about monks or clergy being sensed here – however Alan was picking up on a female presence walking around the perimeter of the Chapel.

ST JAMES CHURCH

Shere

Not far from The Silent Pool (*see separate entry*) is the charming village of Shere. With a bypass built back in the 1960s, Shere has managed to recapture its rural personality with tearooms, pubs and a lovely brook enticing many day-trippers to visit this picturesque spot. I myself was so taken by this stunning location that I used it as the backdrop to my feature film *Return to Ravenswood* in 2005 and I heartily recommend a visit. Indeed, the place does become extremely popular in the summer months – much to the dismay of the local residents!

At its nucleus is the beautiful Church of St James. Like most village churches, this place of worship has undergone much alteration since being built in the medieval period but is still one of the most stunning churches in Surrey.

But St James also has a hidden secret and is related to that of Christine, Anchoress of Shere. In medieval times, people wished to devote their lives to the Glory of God

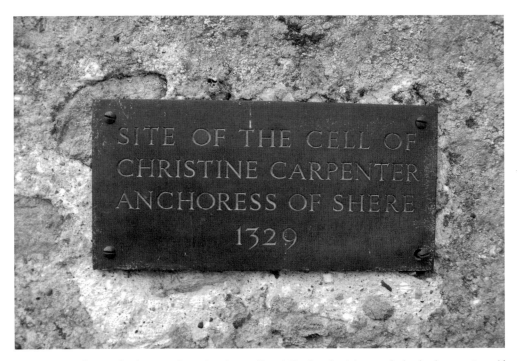

An ultimate form of religious devotion in medieval England with people locked away in self imposed cells away from the wickedness of the world.

Shere's fine old church may hold unknown stories.

and would literally '*anchor*' themselves to a church or religious house, thus locking themselves away until death from the wickedness of the world when they would be released into the Kingdom of God. This was an extreme form of religious devotion and would usually take the form of a stone cell being built onto the building which would be bricked up once the occupant was inside. A small iron-barred window would allow food to be passed through and a small hole was made into the church so the services could still be heard. People from many backgrounds and social standings would perform this ultimate act for God with some wealthy folk even having their servants locked away with them – I wonder what they had to say about *that?*

One such Anchoress was Christine, daughter of a carpenter called William who lived in Shere in the Middle Ages. In June 1329 she had become disillusioned with the world (or at least around the hamlet where she lived) and decided to give herself to God. It was not a case of just '*walling herself up*' but she had to gain permission from the Bishop of Winchester for her to lead a pious life in the service of The Lord. Many people did not last too long once inside their cells so the Bishop was very cautious with potential applications. Christine also had to present her request at St James Church for the rectors and villagers to question her that she was sincere in character, chaste and not engaged to any man.

Permission was granted and a stone cell was built on the north side of the church. With her renouncing her earthly life, she was walled up. She was now officially dead in

the eyes of the world and this must have felt for her the ultimate sacrifice for God and to be free from sin. Unfortunately it did not last; Christine only lasted for three years and managed to escape her holding cell. This brought shame on the village and Christine begged forgiveness to the Bishop who granted her a second chance. It is not known if she continued her enclosure but its very likely as the thought of excommunication from the Church was the ultimate shame among the superstitious of the Middle Ages.

Around the area where Christine cell was situated (there is a plaque on the wall), a female figure has been seen that some say is Christine – walking free once more away from the restraints of her holding cell. Also a strong presence of a man has been felt walking up and down the pathway in the Churchyard and whether these two ghosts are related or not, the story of Christine – Anchoress of Shere lives on to this day.

ST MARY'S CHURCH

Beddington
First mentioned in the Domesday Book, the Church of St Mary's was most likely founded around the time of the Norman Conquest with Robert de Watteville owning the manor shortly after that historic event. It is very probable however that a church or chapel existed here before the present structure as the Bishop of Winchester owned a large estate at Beddington in the early tenth century. Indeed, Bishop Ethelwold (later Saint Ethelwold) died here in AD 984. We maybe able to stretch back even further in time suggesting that the area may have been a sacred site or burial ground during the Roman occupation as two elaborate coffins were discovered on the southern edge of the churchyard.

Closely linked to Carew Manor which occupies the site next to the church (*see separate entry*), most of the current building is of fourteenth century stonework. The second Nicholas Carew who died in 1432 is buried in the chancel beneath a magnificent brass.

It is the adjoining churchyard that seems to be the focus of ghostly activity though. A mass grave of young girls relating from an epidemic when Carew Manor was an orphanage seems to generate a strong female presence around this area and the ghost of a Nun has been was seen many times with a multiple sighting reported as recently as 1972.

ST MARY'S CHURCH

Reigate
St Mary's Church has an impressive claim to fame as England's oldest public lending library. Its hauntings include reports of singing being heard in the early hours and a young girl who walks around up and down a path in the graveyard. She is said to be wearing a long white gown however I'm sure witnesses will not be hanging around to get a full description!

The graveyard here holds stories of mass burials and the sightings of a nun.

STUDIO HOUSE

Wallington

I had come to an undisclosed location in Wallington and at the owner's request (because of the property being a business at the time); we shall refer to it only as *The Studio House*. It was Alexis, the co-founder of the our team, who'd reported that other people associated with the property (as well as herself), had sensed an odd presence in the building and seemed to think it could be that of the business's former owner '*Danny*'. Alexis had known him before he passed over and testimonies from others (including his daughter) seemed to confirm this.

We had done a recce and baseline test a week before in order to establish any potential issues with the investigation. On the night Alexis walked us round the location and talked us through the work they did there. Unfortunately in a last minute absence of the medium, it fell to team member Hannah (a developing psychic in her own right) to take the lead on the walk round. In each room, we each discussed the atmosphere and how we felt in that particular area. Hannah found herself drawn to the corner of Studio 1 and a porcelain dog which belonged to the former owner Danny. I decided to place a personal item as a trigger object by the dog with the camera locked off for a few hours.

Switching the cameras to night vision, we began our evening vigils in Studio 1. As soon as the lights were off, we caught potential light anomalies sweeping past Alexis,

Does its former owner still keep an eye on his business from beyond?

Bryon and Lisa although these were most likely air particles. Everyone felt quite relaxed and calm during this time before deciding to move into the adjoining Observation Room 1. It was here that we attempted a séance to see if we could pick up on anything. Upon calling out, we heard a few faint knocks but this could be down to the natural structure changes in the building. However, a prominent knock came directly after a request for an audio response which startled us suddenly. As is good practice we attempted to gain further knocks but nothing was heard further to this. We also caught a few more light anomalies (or more likely dust) around Alexis who seems to be the focus of most potential activity and this could be because of her association with the location. She pointed out that if it were Danny, he would be most likely laughing his head off at our attempts to communicate with him – apparently he always had a great sense of humour and would be greatly amused by what we were doing!

As the group took a break, I was slightly baffled to find the crew room door shut as this was left open by him – nothing paranormal unfortunately as Byron pointed out that he had shut it after retrieving a camera from there. Alexis at this point took a 'phone call from a friend associated with the premises and gave a few tasters to Danny's personality. Although Alexis kept it from the rest of the team, the friend told her who his favourite singer was to see if it was picked up on later.

After a brief vigil in Studio 2, which didn't seem particularly active, we moved to the second adjoining Observation Room. It was here that we attempted further vocal

communication lead by Hannah. Although nothing was heard, we did capture a couple more light anomalies across the table where we were attempting to have a torch moved that was positioned in the middle of the table. A few minutes later and out of the blue, Hannah just said '*Elvis!*' – this indeed was Danny's favourite singer and she also pointed out that she had visions of him dancing away in life to Elvis in the Studio areas, which Alexis once again confirmed. Hannah made it known that she was focused on the torch and nothing else when this image popped in her head.

We ended the evening with a further vigil in Studio 1 and although we picked up a further light anomaly, nothing else was reported. Lisa however, took the camera and explored the bathroom area, as this had been a strong link to the dowsing tests earlier – she had to laugh though as she had forgotten to press the '*record*' button until a few minutes later! She did pick up an unusual '*hush*' sound and closer analysis of this recording seems to indicate that the noise overlaps her own voice as she speaks into camera.

For a small investigation, the results had proved very interesting. The trigger object placed in Studio 1 had produced no activity but knocks, the odd strange voice and anomalies had given the team opportunity for open-minded discussion. Were these paranormal occurrences or do they have a natural explanation?

SWAN CORNER

Leatherhead
Back in the 1930s, several motorists reported seeing a tall spectral woman standing in the middle of the road only to promptly disappear. On one occasion a truck driver thought he had hit this phantom woman and killed her only to discover when he went to search for the body that no one was there. Apparently a short time after these events, the woman was seen as a nun who would be laid out in the road only to once again, promptly vanish!

SYDNEY NEVILLE LEVITT

Sutton
The following sad story is not exactly a tale of ghosts but a poignant reminder of the horrors of The Great War of 1914–1918 and of a brave man who may have predicted his own death.

Sydney Neville Levitt was born on 6 November 1898, lived in Mulgrave Road in Sutton and was awarded a scholarship to Sutton County School. At the school he excelled in a number of sports including cricket (he was the Captain), swimming and football as well as being a member of the debating society and enjoyed writing poetry. Sydney left school in 1916 and was posted to the Army Training Reserve in 1917 before being commissioned to the Kings Royal Rifle Corps.

Of course, this was during the First World War and Sydney found himself among the trenches in Northern France. At 5.30am on the morning of 29 September 1918,

he found himself in a trench by a hill with the 16th Battalion. They were under heavy attack from the enemy with a thick gas barrage separating the soldiers of the company. Sydney who was a 2nd Lieutenant found a few men and attempted to find a way through the dense fog – but to no avail. His body along with his fellow comrades was found the next day close to enemy lines. Sydney Neville Levitt is buried in Northern France with the other brave members of his Battalion.

Shortly after Sydney was killed in action, a poem of his was uncovered that tragically might have prophesied his own death:

Abschied Vom Leben,
The wound burns; my quivering lips are pale,
My heart is nigh to burst beneath the strain,
Now I await the end of Life's short reign,
And breathe 'Thy Will Be Done'. Nought can avail,
For now the shadows of Death do e'en assail
Mine eyes, where golden piece had once domain.

Yet courage, heart! The fond ideals we gain
On earth must live with us beyond Death's pale,
And what I held as sacred here below,
That which set youthful ardour all aglow,
The pride of freedom and the charm of love,
I see their forms seraphic up above,
And as my body sinks down into Night,
They bear my spirit upwards to the Light.

THUNDERFIELD CASTLE

Horley
Once belonging to Chertsey Abbey (*see separate entry*) this medieval ring and bailey Castle was recorded in their documents as '*3,000 acres in the manor of Sutton with a den for pigs*' although some of the Abbey's records are now believed to be fabricated. First mentioned in Anglo Saxon documents around AD 880, the castle is now overgrown with trees and greenery and can only be reached by a narrow track from nearby Smallfield Road.

At dusk, a phantom bell tolls as an army of soldiers walk toward what is believed to be a resting place for King Harold's men as they marched to the Battle of Hastings in 1066.

TUNSGATE

Guildford

Originally in front of what was called The Three Tuns Inn in Guildford stood the town's gallows and it was here on 9 July 1709 that the rather unfortunately named Christopher Slaughterford was executed. Slaughterford, who lived in nearby Shalford had been found guilty of murdering his lover Jane Young and of disposing her body in a pit at nearby Loseley.

Although there seemed to be insufficient evidence to support the crime (Slaughterford had already been acquitted once), locals at the time were convinced of his guilt and although he continued to plead his innocence, he was finally condemned and hanged. It does seem likely however that the magistrate was bowing to public pressure regardless of any concrete proof of his guilt.

Almost immediately after his death, people started seeing Slaughterford's apparition around both Guildford and Shalford in the most distressed state with the spectre chillingly screaming '*Vengeance, Vengeance!*' Reports of this apparition persist to this day and maybe these screams are of a man innocently killed all those years ago?

VERNON HOUSE

Farnham

Farnham Library now occupies part of the building that was formerly known as Vernon House. It was here in 1648 that King Charles I was held on the way to his trial in London.

It is said that a smartly dressed man of seventeenth century attire has been seen around the stairway and upper floors. This apparition has been linked to that of the doomed Charles although how people make that connection is uncertain!

VESTRY HALL

Mitcham

This grand building was constructed in 1887 to commemorate Queen Victoria's Golden Jubilee. Situated near Mitcham Town Centre, the Hall was designed by local architect Robert Masters Chart who would also become the first Mayor of Mitcham in 1934 at the age of eighty-four! Mitcham Borough Council occupied the site from 1934 until 1965 when the town along with Modern and Wimbledon merged to form the London Borough of Merton.

At the top of the building is the old caretakers flat and it is said that that the caretaker still wanders about the upper floors with the Centre Manager having said '*there is most definitely a chill which catches you unawares!*'

WATLING STREET

Virginia Water
Around AD 60 a fierce battle was fought here between the Romans and the Britons led by the warrior Queen Boudica (or '*Boudicca*' or '*Boadicea*'). Although there is much speculation as to the exact location of the battle, the Roman Tacitus described the land as '*being approached by a narrow defile with a wood at the back and a plain in the front*'.

The Roman Commander Suetonius gathered a force of 10,000 men from both the 14th and 20th Legions against the alleged number of 250,000 Britons. In a rousing speech, Suetonius addressed his Legionaries:

> '*Ignore the racket made by these savages. There are more women than men in their ranks. They are not soldiers – they're not even properly equipped. We've beaten them before and when they see our weapons and feel our spirit, they'll crack. Stick together. Throw the javelins and then push forward: knock them down with your shields and finish them off with your swords. Forget about booty. Just win and you'll have the lot.*'

At the close of battle, it was estimated that the Romans killed 80,000 men, women and children against Roman losses of just 400 and this promptly ended the revolt (at least for the time being). Whether this was the site of that horrific battle or not, there have been many reports of Roman soldiers having been seen and almost 2,000 years after the event – the Legionaries may still be playing out that decisive conflict to this very day.

WAVERLEY ABBEY

Waverley
Set in a picturesque meadow next to the River Wey, Waverley Abbey was founded in 1128 by Bishop William Giffard and was the first Cistercian Abbey in England. Providing shelter for weary pilgrims (possibly on their way to Canterbury) and an infirmary for the sick, the Abbey grew steadily until Henry VIII's Dissolution of the Monasteries in 1536 changed the face of religious order across the country. After this time the Abbey became an unfortunate source for building materials, most notably for nearby Loseley House (*see separate entry*) and the Abbey today is just a former image of its magnificent heyday. During the life of the Abbey, the Cistercian Monks built many bridges and structures around the area including Wanborough Barn in Guildford in 1388, one of the finest medieval barns in the country. Waverley Abbey today is managed by English Heritage and is a free open access property.

As can be expected from a location like this, apparitions of monks have been seen many times as well as the sound of chanting coming from the Abbey ruins. There are also rumours of hidden treasure somewhere within the grounds but once again this is probably more folklore than any existing evidence. There is also an allegedly true story from medieval times of a boy who fell from the top of the Abbey and seemed to lie

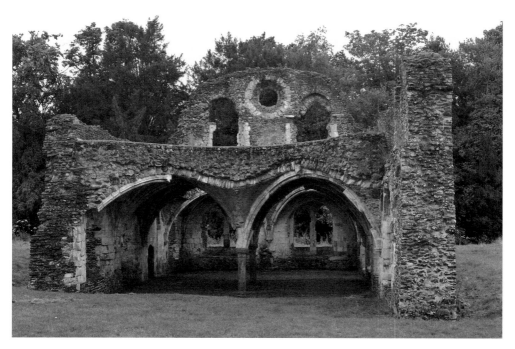

The first Cistercian Abbey in England, its rich history has been full of tales of ghostly monks.

dead on the ground for a time but miraculously recovered without any injury to him. The seventeenth-century writer John Aubury commented on this in one of his journals *'In 1228 a youth fell from the top of this Church and lay for some time stupefied but recover'd without hurt or pain.'*

When I have visited here with a medium however, we seem to be followed by a female figure of a much later date!

WEST CLANDON

Clandon
As with the tale of the Buckland Shag, Old Surrey lore has a number of stories about fierce beasts which roam the countryside looking for its next victim. This following article appeared in a 1796 edition of the *Gentlemen's Magazine*:

> *'A serpent once infested a back lane in the paraish of West Clandon for a long time. The inhabitants were much disturbed and afraid to pass that way. A soldier who had been condemned for desertion – promised, if his life was spared, he would destroy the serpent. Accordingly he took his dog with him. A fierce battle ensued, the dog fastened him and the soldier killed it with a bayonet in a field belonging to the glebe called Deadcare.'*

This house was the home of WILLIAM MULLINS a Pilgrim Father who sailed on the "MAYFLOWER" to America on 16th Sept 1620

Many shops along this street in Dorking have reports of apparitions and unexplained phenomena.

WEST STREET

Dorking

Just off Dorking's main High Street is the historic West Street and some of the shops along here have had a long reputation of being haunted. The main apparition is that of a man usually seen around 58-60 West Street and has been linked to the ghost of William Mullins.

Mullins was a Christian Puritan who owned a large chunk of land around the Dorking area but is more famous for joining 101 fellow Christian pilgrims aboard The *Mayflower* in September 1620 to venture to the New World. Tragically, upon landing at what would be called New Plymouth, the harsh winter of the upper east coast took its toll on the settlers and half of them died in the first few months including Mullins, his wife and son.

WHITEHALL

Cheam

Built in the 1500s and with a strong link to The Old Rectory and Lumley Chapel nearby (*see separate entries*), Whitehall is a large Tudor house with original wattle and daub timbering. When it was originally built, Cheam itself would have been a small rural community of just a few hundred people centered around Park Lane and Park Road. There may have been a Tudor Inn on the site of The Harrow Pub today and near Whitehall itself was a Blacksmith's forge. Even before the present building was constructed, the name '*Whitehall*' may have derived from '*Wight's Hall*' as a family called Wight lived in the area of Cheam back in the fifteenth century although there is no evidential connection between the house and the records.

The Killick family lived here for over 200 years and is their presence that has been reported here?

The Killick family lived here for over 200 years with an 1881 census stating that School Masters John Tancock, Walter Dayman and Montague Grignon lodged in Whitehall with Charlotte and Harriet Killick and their servant Ann Baker. There is a possible report from 1959 that one of the last members of the family to live here, Harriet Maud Muller was accidentally killed by a motor car as she crossed the main road after leaving Sunday service at St Dunstan's Church opposite. After her death the house passed to a niece for a few years until 1963 when it was passed over to the local authority ending two centuries of occupation.

Whitehall also has its share of ghosts and with the Killick's long association with the house, maybe it's them who still reside here. A member of that family called '*George*' is apparently still around, walking along the corridors of his former home as well as an apparition of a lady (who seems be a nurse) that medium Alan Barnett picked up on at the Old Rectory sometime later.

WHITE HORSE

Dorking

Along Dorking's historic High Street is this delightful fifteenth century coaching inn with original fixtures dating back to 1750. This 3-star hotel also has original timber beams and open fireplaces.

Charles Dickens once stayed here but it's the Ninth Duke of Norfolk who apparently remains at the inn as he is too drunk and intoxicated to able to return to lodgings at Deepdene House.

WIMBLEDON COMMON

Wimbledon

I'm afraid there are no Wombles on Wimbledon Common but it does have its fair share of more sinister inhabitants that may still reside here many years after their demise. To the of the west of the Common lies the remains of an Iron Age Hill Fort called *Caesar's Camp* which was constructed around 600 to 800 BC. Although the Camp's name has nothing to do with Caesar or the Roman occupation, the ghosts of centurions have been seen around this area over the years.

In the eighteenth century, the notorious highwayman Jerry Abershawe and his gang worked the area around Wimbledon Common and was a man in the same league as the infamous Dick Turpin. Operating out of an Inn called *The Bald Faced Stag* on the old Portsmouth Road, Abershawe frequently lifted travellers of their money and cargo as this road was a busy route to and from London. He managed to evade capture for five years until 1795 when he shot and killed a Bow Street Runner and was arrested. Sentenced to death, he was hanged on Kennington Common although his body was

Does the Ninth Duke of Norfolk still remain at this hotel, too drunk to get home?

taken down and hung from gallows on what is now called '*Jerry's Hill*' by The Windmill in the northernmost end of the Common.

Abershawe's ghost has been seen on horseback galloping across the Common at night and is still maybe looking for victims all these years later.

WIMBLEDON THEATRE

Wimbledon
 '*For beauty and size Wimbledon Theatre would not disgrace*
 Shaftesbury Avenue'

So wrote a journalist from *The Times* at the opening of this grand Edwardian theatre on Boxing Day 1910. Of course, Wimbledon is world famous for its annual tennis tournament but standing proudly along The Broadway is the prominent landmark of Wimbledon Theatre (or *New Wimbledon Theatre* as it's now called). The Theatre was founded by entrepreneur J. B. Mulholland and designed by Cecil Masey and Roy Young. Mulholland was a man with a vast passion for the arts and already owned venues in Hammersmith and Camberwell.

All the biggest producers in the business brought their shows to Wimbledon featuring the best star names of the day such as Matheson Lang, Julia Neilson and Fred Terry and in later years the likes of Marlene Dietrich, Gracie Fields, Sybil Thorndike, Ivor Novello, Noel Coward and Laurel and Hardy. During the Second World War, Wimbledon Theatre did its best to remain open despite heavy air raids and did suffer several near misses during the Blitz. To show resilience, Winston Churchill's wife organised a Charity Concert in aid of war refugees with the famous Flanagan and Allen leading the entertainment.

Now many theatres across the country lay claim to paranormal activity within their venues and Wimbledon is no exception. The theatre's archivist Maurice Wareing told me that he was conducting a tour of the building with members of the public a few years ago and a lady experienced the pressure of a strong female energy by the front of the stage and was almost knocked back by the force.

A few years ago in the upper circle, an usher was clearing away after a performance and heard a woman whistling from the ladies' lavatory. Thinking a patron was still in the building, she called out that the theatre was closing – only to find when entering the toilet that no one was there! Also back when the theatre was new, part of a set collapsed and allegedly killed an actress (this can't be confirmed unfortunately) and the presence felt within the theatre is said to be her. One time General Manager Mike Lyas; who had worked at the theatre for years (and didn't believe in the ghosts!) was working late one evening when a woman in what seemed to be Victorian or Edwardian clothing stood there in front of him. He only saw her once but had been told she was beautiful.

On another occasion, the theatre's sprinkler system was activated for no apparent reason. Back in 1980, the venue was undergoing a £3 million refurbishment and the fire brigade had been checking the valve system that operates the sprinkler. All

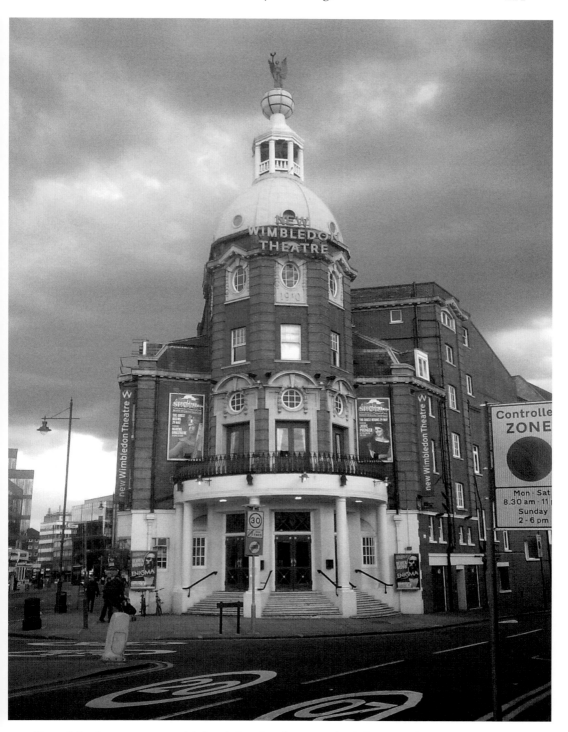

Unexplained occurrences at this South London theatre make it deserving for its reputation as a very haunted building.

Does theatre entrepreneur J. B. Mullholland still watch over his venue from the Dress Circle seats?

equipment had been checked and they were satisfied it was operating correctly. At about 2am in the morning, the manager was awoken to the sound of the alarm bell and rushed down to the auditorium to find the sprinkler system drenching the stage. Incredibly the set which was on stage at the time escaped with very minimal damage and the valve handling unit was found to be still working properly – the fire brigade upon investigating also could find no fault with the machinery.

A psychic reading of the venue by medium Alan Barnett revealed some further interesting information. A very strong female presence was picked up on at the front of the stage area and moves around the stalls auditorium. Alan described her as an Edwardian lady with a full-length dress and fair hair and seems very much interested in the care of the theatre; could this be the same lady who affected the woman on the tour? On the stairway leading to the Upper Circle, Alan had the sensation of a fire or flames, which could be from the old Manor House but we can't find any reports of any blaze from the archives – it may have been where the old house had its chimney? In what is now the Ticket Call Centre, there used to be the theatre's living quarters and in the late 1970s, the Manageress staying there was awoken to see an elderly lady standing over her and then elevating up through the ceiling and disappeared!

Alan also sensed a man dressed in smart evening wear wandering through the corridor and entering the auditorium where he sits in the Dress Circle to watch the shows (in seat B27 to be precise!) – could this be the spirit of J. B. Mulholland who still keeps a watchful eye over his favourite theatre? And if Mulholland is still wandering around then an apparition seen in 2004 might very well be the man himself?

Having worked at the venue for a number of years, I conducted a Ghost Tour of the theatre as part of the Centenary Celebrations in 2010. As well as mentioning the above stories and reports I conducted a séance on the stage with both members of the public and staff. Medium Alan Barnett sensed the Edwardian lady moving about the circle with a sense of curiosity at what we were doing (which I'm sure must have looked peculiar to say the least).

Two of my colleagues Joe and Paul told me that they were backstage in the crew room and were the only people in the building. They were suddenly alerted by the sound of the lift's automated voice saying '*Ground Floor*!' and the doors opening and closing. Whether this was a fault with the lift or not, this has never happened before when no one had been in operation of the elevator.

I shall end with one last little tale that happened to me one Sunday. I was backstage in the crew room when a hardhat that had been on a high shelf for many weeks literally flipped up in the air and fell to the floor which naturally startled me somewhat. I felt the only thing I could do in my astonished state was say '*Thanks*'. Pity there was no reply back!

WOOTON HOUSE

Dorking

This house has been much altered since it was originally built in Tudor times and is well known as the birthplace in 1620 of diarist and horticulturalist John Evelyn. Indeed, the house was the Evelyn family seat for many years until the early 1980s when the house was used as a College for the Fire Service.

There seems to be much ghostly activity occurring here with night staff reporting the most phenomena with objects being moved, doors opening and closing by themselves and inexplicable cold spots. It was in 1964 that Mr Welch, a nightporter witnessed the main front door open and the figure of a man walk in. Mr Welch described the apparition as Dickensian looking with a tweed jacket and what appeared to be fishing tackle under his arm. Mr Welch found the gentlemen to have a kind and harmless disposition and said that '*I did not have the cold sensation and was not in the least alarmed!*'

A very bizarre tale also occurred here in 1873. Dr Samuel Wilberforce, the Bishop of Winchester (*see Farnham Castle entry*) and son of William Wilberforce, the abolitionist was out riding his horse through Deerleap Woods with a companion. Samuel commented that he would like to visit Wooton House nearby to see a painting of Mrs Godolphin, the subject of a book written by Samuel about her.

Was it Dr Samuel Wilberforce who was seen at a window at the same time he was tragically killed in a riding accident?

Very soon afterwards, he was tragically thrown from his horse and killed. At the same time of the accident over at Wooton House, four people including two Evelyn brothers were in the dining room and reported seeing Wilberforce peering through the window who was recognised by one of the brothers William, who had met him several times. The men went outside to see if Dr Wilberforce was there but no trace of him could be found – it was only a few days later that news reached Wooton House of Samuel Wilberforce's tragic passing.

WRYTHE LANE

Carshalton

An old friend of mine called Samantha told me of some strange ghostly occurrences that were prevalent in her old family home along Wrythe Lane in Carshalton. As a teenager, I would often visit this home with friends but at the time had no idea that other '*people*' were possibly in the house with us as Sam explains:

'*There were things like an old lady sitting in a chair in my sister's bedroom, as well as a man standing over the bed looking down at her. My mum said she had some experiences of a tall figure standing over the bed too. Another occasion somebody whispered in my mum's ear to 'open your eyes'. I had an experience where I was standing on the landing and went to pull my bedroom door shut so that my hand was on the other side of the door (if that makes sense) and someone scratched my hand. I know it all sounds silly but there was weird stuff going on in that house*'.

YE OLDE RED LION PUB

Cheam

The oldest public house in the London Borough of Sutton, Ye Olde Red Lion in Cheam Village is situated within the vicinity of The Old Rectory, Whitehall and Lumley Chapel *(see separate entries)*. It has stood here for over 400 years with much of its original exterior still intact as well as its low-beamed ceiling. There is a well at the front of the pub and was used for many years until as recently as the 1930s.

The pub is said to be haunted by a strong male figure who walks through the bar area at various intervals. Interestingly, medium Alan Barnett picked up on a murdered man from the eighteenth century who was killed by two men by being pushed down the Well at the front of the premises. When we investigated *The Old Rectory* sometime later, Alan sensed this same man's body being taken to the Rectory's cellar until the unfortunate victim could receive a proper burial. Bodies were usually placed in the cellars of inns (as they were obviously cooler) and this was quite common practise in small villages in days gone by before the introduction of morgues.

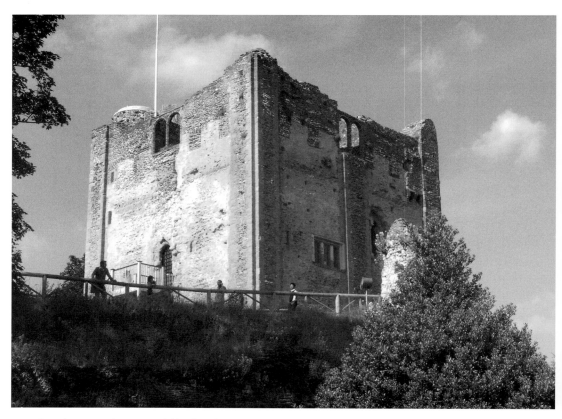

Standing guard over Guildford is the magnificent Keep of Guildford Castle.

SO YOU WANT TO BE
A GHOST HUNTER?

I have only scratched the surface of this county's haunted locations and like many other places in the UK, there is much more to see if you dig a little deeper and see what fascinating mysteries exist underneath the landscape and its history.

Maybe you know a few more untold stories of Surrey, or even from your own county and feel an urge to explore these places yourself. If you investigate with an open and inquisitive mind, you could be rewarded with uncovering a lot more information that compliments the already existing history.

So let's take it to the next stage. You have visited places with claims of paranormal activity and heard stories of people who have had unexplained experiences and you want to dig deeper and investigate yourself – so what do you do?

Below are some frequently asked questions I receive regarding ghost hunting and I hope it will give you an insight into the practice of being an investigator.

How do I find locations that have reports of paranormal activity?
The internet is a great resource for researching locations that have claims of supposed hauntings. Look around your town and in your local library to see if there are reported incidents from your area and try to interview potential witnesses. Alternatively, you could book a ghost hunt with one of the many reputable companies that organise investigative experiences at many locations across the country; you will find links to these at the end of the book.

What equipment do I need?
I'm sure many people have watched the paranormal TV shows with all their electronic paraphernalia and these can be useful on investigations. It is important to note that these devices were not designed as '*ghost hunting*' kit but have been adapted from their original purpose to aid the investigator.

The most commonly used equipment are digital cameras and camcorders with infrared beams (ultimately having something captured on video is the main goal). You can also use EMF meters, which record the electromagnetic field of an area as well as an Audio Dictaphone to record possible EVP (Electronic Voice Phenomena). There are many experiments that you can undertake and really anything is worth a try. Below is a basic list of equipment that many investigators choose to take on investigations that may help you:

- Digital Cameras
- EMF Meters
- Digital Audio Dictaphones
- Beam Detectors
- Enhanced Microphone and Earpiece
- Thermal Imagers
- Torch
- Note Book and Pen.

However, the best resource on an investigation is yourself – go in with an open mind and you will be surprised by what you may experience?

Do I need to investigate in the dark?
There are a few reasons why we investigate in the dark; one is that you are out of your comfort zone in the dark and much more alert to any alleged activity, also it is much easier to capture any potential evidence on camera. Another reason is that it is much quieter with much less external sound. Of course there is no rule of thumb that says you can't investigate during the day (which I have done in the past).

Are Séances and Ouija safe?
Regarding Ouija, its only misinformation that has contributed to the negative press it receives. It's just a tool like any other such as glass divination but as a rule myself; I don't generally use them, as they are not a reliable form of experimentation. Séances are fine and I have used his method on investigations like many others do.

I have photographed an orb on camera, is it paranormal?
There is much controversy regarding orbs but as far as I'm concerned, they are just light refractions, dust, insects or atmospherics. If orbs are '*spirit*' as many claim then it surely has consciousness so there needs to be some sort of interaction experimentation to test this. You will find that many people claim something is paranormal without looking at the other alternatives.

I hope you will find this information useful on your paranormal travels and once you start investigating, you will find it opens a floodgate to a fascinating world and you never know, you may be one of the lucky people to witness a *ghost!*

One last thing to remember is to question everything as what might appear as paranormal activity may not be after close scrutiny.

Good Luck!

SPIRAL PARANORMAL

As well as being an independent researcher of the unexplained, I also have my own team at *Spiral Paranormal*. The group was established back in December 2006 following the completion of my first feature film *Return to Ravenswood*. Spiral approaches the world of the paranormal visually with video episodes being shared online for free download. Some of these episodes have had repeated broadcasts on *The Unexplained Channel* on Sky TV. Each Episode averages 10-20 minutes in duration and available in a variety of viewing formats. Our main aim is to show an honest depiction of paranormal investigations and we always say that if we get nothing – we will show nothing.

The team is made up of both believers and sceptics (guess which one I fall into?) and approach investigating the paranormal with an open mind and although we use standard equipment, we also like to have plain old instinct and fuse both rationality and spirituality among the team in order to produce potential results. We do not claim to be looking for definite proof of ghosts (because lets face it, it's pretty much impossible!) but provide any potential activity for viewers to decide for themselves. Although we have a core team, we often work jointly with other groups, individuals and Event Companies. This is something we wish to continue, as we are of the mindset that information gathered should be a shared.

So in our quest for paranormal activity, have we experienced anything that could be defined as '*unexplained*'? Well as mentioned in the introduction to this book, what might be paranormal for one individual may not be to someone else but I'll detail a few incidents from over the years that even I have scratched my head over.

We had been contacted by a lady called who was interested in seeing what alleged spirits had been making their presence known in her home. This was our first investigation with medium Alan Barnett who has been the resident psychic with *Spiral Paranormal* since 2007 and is very much a raw medium and the type I like to work with. This investigation also introduced both Patricia and Duncan to the team who have also been with us since 2007. It was during the early hours of the morning during

Spiral Paranormal in 2009 at The Chequers Inn.

the investigation that we joined Duncan in the spare room downstairs. He had recorded a very interesting ENP (what I like to call an *Electronic Noise Phenomena*) whilst we had been upstairs on a quiet vigil. Playing back on headphones, it sounded very clearly and audibly like a door opening and a shuffling of feet. With everyone accounted for (and we were all sitting down at the time) and no doors shut at this point, we were bewildered at to what this could be. With Duncan being very knowledgeable about sound engineering, he assured us that he was sitting quietly during the one minute of recording and heard nothing at the time. Even now I find this recording intriguing and natural audible sound in the house had been accounted for.

On another investigation in 2007 (and what I like to think our most active investigation) we had visited Abingdon Town Football Club. The Club was founded in 1870 and is the sixth oldest Football Club in the UK. Things started slowly as we didn't arrive at the location until 10.30pm and had to wait for the punters to leave but it was in a Bar Room upstairs and a communication circle around a small table that produced some very interesting results. Medium Alan Barnett led the séance and was startled to hear very loud and definite taps on the table to almost all questions asked. Alan asked to tap once for '*yes*' and twice for '*no*'. On a further session we asked again but silence – then a tap on the table that continued from the questions being asked (such as are you male or female etc). Alan asked if there was more than one spirit in

Spiral Paranormal at Beyond the Senses in 2010.

the room and one after another there were prominent taps and we counted seven. Alan asked if our energies combined with the spirit's could lift the table and here is where it became very interesting.

After a few minutes the table lifted towards each of us. Now, the prominent taps would have been good enough but when the table elevated many times on command, we could hardly believe what we were seeing. I have always questioned this sort of table tipping in the past but I was constantly checking under the table to make sure everyone's feet were away from the legs of the table (it's worth noting, the table was also quite heavy!). We were all pretty amazed at this point (even me – that's a first!) as the table then tilted further to one side with everyone's fingers lightly touching the sides. As this was happening, we realised that the Dictaphone was just sitting in the middle of the table, when the table tilted to one side, the Dictaphone never moved! One of course would expect an object to slide off the table but it just sat there. Team member Vicky lifted the Dictaphone off the table and it was obviously not stuck there at all.

During this session and according to some in the group, the spirit apparently did not want to be filmed and people felt irritation in the air. Alan asked another time *'Are you sure you don't want us to film you?'* and there was another loud tap. Luckily on the second session, I managed to get plenty of video footage of this phenomena and it is very compelling footage, filming the table from all angles to make sure no

Team member Patricia and myself at the Viaduct Tavern.

human error was at work. This continued until around 3am when our time there had to finish (obviously we wanted to continue but had to vacate the premises). As we packed up and started to leave the room, we realised that the trigger objects (three coins) had moved whilst all the table communication was going on. This was still our most interesting investigation but of course it is worth noting that there will always be a natural explanation to phenomena but on this occasion, I still haven't found one.

Of course any team's dynamic is down to the individuals involved and I'd like to take this opportunity to thank the *Spiral* members past and present for their hard work and support over the years.

Our Episodes can be downloaded and viewed at the following websites:
www.spiralparanormal.co.uk
www.youtube.com/spiralinvestigations

ABOUT THE AUTHOR

Marq English has had a life long interest in many aspects of the paranormal including researching crop circles and ley lines but has a particular fascination with the phenomena of spirits, ghosts and hauntings. Ever rational in his approach to the subject, he strives to offer alternative explanations for alleged phenomena although very open minded to the possibility of continued consciousness and phenomena.

Marq is also a filmmaker and actor and over the years has directed an assortment of short films and documentaries with some having been broadcast on television including the comedies *Shelf Life* (2003) and *Whatever Happened to Mark Fielding?* (2006). In 2007 he wrote, produced and directed his first feature film *Return to Ravenswood* and 2010 saw the completion of the *Doctor Who* documentary *FANZ*. Freelancing he has worked on projects for Ambassador Theatres and the Royal Navy during the Trafalgar 200 Celebrations in 2005. Marq is also the founder of *The Sutton Film Festival* which was established in 2002 to showcase short films from new and established directors.

As an actor he has appeared in various films including the features *Incidental Weekend* (2008) and the vampire movie *Blood + Roses* (2009). He has provided voice over work for a *Doctor Who* audio play opposite Peter Davison for BBC licensed *Big Finish Productions*, played Corgill in the radio pilot *City of the Saved* and radio trails for BBC Worldwide to name but a few. Marq also spent three long summers in the late 1990s teaching drama on an American Summer Camp in New Jersey.

Along with his team at *Spiral Paranormal*, he produces a series of online video episodes and diaries which are available for free download from the Spiral website – *www.spiralparanormal.co.uk* with selected episodes having been broadcast for *The Unexplained Channel* on Sky TV. Working for Norie Miles of *Out There Media* he has also filmed projects for parapsychologist Dr Ciaran O'Keeffe and Steve Parsons of Para.Science, paranormal historian Richard Felix and event companies such as *Compass Paranormal* and *Fright Nights*.

Marq has written for various publications including *Paranormal Magazine* and *Ghost Voices Magazine*. He has been invited to discuss his views on the unexplained for many radio shows including *White Noise Radio, Now That's Weird, UKPN Radio* and *BBC Radio*. He was also the paranormal advisor on the *Quay FM* Radio show *Tuning In* back in 2008.

He continues to research and investigate alleged paranormal phenomena and is always keen to hear about people's experiences and possible haunted locations.

Marq resides in Carshalton and his house is *not* haunted!

The author, Marq English.

USEFUL WEBSITES

If you are interested in further study of the paranormal world or maybe wish to take part in a public investigation event, please visit the following websites for more information:

Compass Paranormal Events – *www.compassparanormalevents.co.uk*
Dead Haunted Nights – *www.deadhaunted.com*
Dr Ciaran O'Keeffe – *www.theparapsychologist.com*
Ghost Voices Magazine – *www.ghostvoicesmagazine.com*
Mysterious Britain – *www.mysteriousbritain.co.uk*
Phantom Force – *www.phantomforce.co.uk*
Paranormal Magazine – *www.paranormalmagazine.co.uk*
Para.Science – *www.parascience.org.uk*
Spiral Paranormal – *www.spiralparanormal.co.uk*
Supernatural Tours – *www.supernaturalnights.co.uk*
UKPN Radio – *www.ukpnradio.webeden.co.uk*
White Noise Radio – *www.whitenoiseradio.webs.com*

BIBLIOGRAPHY

Ghosts of Surrey John Janeway (1991)
Haunted Places of Surrey John Janeway (2005)
History of New Wimbledon Theatre Robin Cooper & Maurice Wareing (2004)
Mysterious Wimbledon Ruth Murphy & Clive Whichelow (1994)
Surrey Lore and Legend Michael Lane (1999)
Tales of Old Surrey Matthew Alexander (1985)
Unknown Ghosts of the South East Andrew Green (2005)
Walks into History – Surrey David Weller (2008)